The Flower Painter's
Essential Handbook

JILL BAYS

D&C
David and Charles

A DAVID & CHARLES BOOK
Copyright © David & Charles Limited 2006

David & Charles is an F+W Publications Inc. company
4700 East Galbraith Road
Cincinnati, OH 45236

First published in the UK in 2006

Text and illustrations copyright © Jill Bays 2006

A catalogue record for this book is available from the British Library.

ISBN-13: 978-0-7153-2246-8 hardback
ISBN-10: 0-7153-2246-X hardback

ISBN-13: 978-0-7153-2248-2 paperback
ISBN-10: 0-7153-2248-6 paperback

Printed in Singapore by KHL Printing Co Pte Ltd.
for David & Charles
Brunel House Newton Abbot Devon

Commissioning Editor Freya Dangerfield
Project Editor Ian Kearey
Assistant Editor Louise Clark
Art Editor Lisa Wyman
Senior Designer Sarah Underhill
Production Controller Kelly Smith

Visit our website at www.davidandcharles.co.uk

David & Charles books are available from all good bookshops; alternatively you can contact our Orderline on 0870 9908222 or write to us at FREEPOST EX2 110, D&C Direct, Newton Abbot, TQ12 4ZZ (no stamp required UK only); US customers call 800-289-0963 and Canadian customers call 800-840-5220.

'Has anyone ever seen anything like Winsor & Newton's cups of Chrome and Carnations and Crimsons loud and fierce as a war-cry, and Pinks tender and loving as a young girl?'

Charles Dickens

Contents

Introduction

Painting flowers is not just about creating a still life of some blooms in a vase or jar: it opens a whole new world of painting. Think of the variety of shapes, sizes and patterns, and the range of colours and settings you can explore. There are also many ways of painting, from being free and loose with the brush, to being a super-realist and painting every detail. However you feel, there is a way to achieve the result you want.

your subjects

Even in a small window box or tiny garden, there is an amazing variety of shapes and colours. As an artist, how do you go about selecting your subject? You are probably familiar with your own garden of plants, but even in this situation a lot can depend on outside factors such as light, heat, shade and the weather; and in public gardens, other people walking around can be distracting. Start by finding something that appeals to you immediately, and get the ball rolling by making small sketches of your subject.

There are various approaches to painting flowers and plants. You can choose to paint a close-up of a single subject, in isolation or with the hint of a further dimension, or you can go for the long view, a landscape interpretation that includes flowers or foliage. Keep your options open, and always make sketches to help get your thoughts in order and organize your priorities.

inspiration and challenge

When faced with a new subject to paint, you really should want to paint it, but sometimes inspiration doesn't come immediately, you should be open to becoming more interested as you paint. Don't be put off when this happens, as we can all get stuck in the same ways, and it can be difficult to break out.

Look for the challenge that can come from investigating new shapes and forms, perhaps in a way you haven't explored before. Using different paper and deviating from your usual colours can often inspire you to innovative approaches.

Sometimes painting in a completely free way – going straight in with the brush without any preliminary drawing, for example – can start you off. At other times, carefully thinking out your strategy beforehand can be useful: a considered still life and selection of colour combinations, with preparation in the form of colour roughs and drawings, can be a great help.

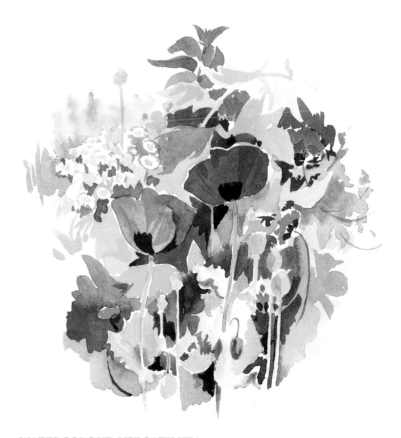

WATERCOLOUR VERSATILITY
This painting shows a variety of colours and applications; some paint is thick and dark, other washes are light and pale; some colours are painted straight on to the paper, while others are painted over one another.

working outdoors

If you are like me, then a great deal of your outdoor sketching is likely to take place in your own garden, or a garden or situation that you know well, so you become very familiar with its particular viewpoints and thus have plenty of time to think about the subjects you want to paint. Away from such familiar places, however you have to choose more rapidly.

Outdoor sketching is great fun: you have to gamble on the weather and be prepared for anything. Travel light and cut down on equipment, but always take something to sit on, a hat and sun cream. Go with the right attitude, be prepared to make lots of thumbnail sketches, and don't worry if you don't complete anything in situ.

a word about sketchbooks

A sketchbook is an essential part of your equipment – use it for ideas, sketches, even painting. It is your primary source book, so carry it everywhere and make sure it is readily to hand. Some artists use their sketchbooks as a kind of diary, and draw in them every day.

There are many different sizes of sketchbook. I find one with A4 cartridge paper very useful for most purposes, and also have some containing heavier weights of watercolour paper, which are perfect for taking on holidays as they don't need to be stretched. Smaller books are excellent too as they can be slipped into a pocket or bag and used in crowded places. There is also a choice of bindings, the two most popular being spiral bound or pads with soft or hard covers. You could also make your own sketchbooks using your favourite papers, which will then become very personal records.

how to use this book

Starting with a brief look at the equipment available to you – paper, paints, brushes and accessories – I suggest a useful selection. The next section covers the basic techniques: the brushstrokes you can make, and how to create a variety of washes. The two fundamentals of watercolour painting are then illustrated – working wet into wet and wet on dry. A study of flower shapes and patterns and the details of stems, leaves and grasses follows, with advice on colours and how to create them for flower painting. Tips and advice on light and shade and tone, two invaluable allies of the painter, conclude this section.

The main part of the handbook takes an in-depth look at 50 flowers, ranging from humble daisies to exotic orchids and luscious peonies. Each spread features drawings and sketch studies with pointers on what to look for; a watercolour study, again annotated; a palette of recommended colours and step-by-step instructions on how to paint the flower. To inspire your own work, a finished painting, in a style ranging from loose and free to more detailed, features the subject in a variety of approaches.

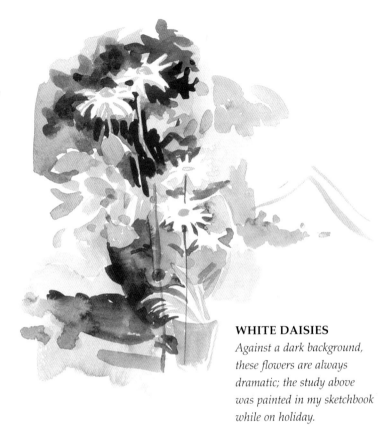

WHITE DAISIES

Against a dark background, these flowers are always dramatic; the study above was painted in my sketchbook while on holiday.

PLANT STUDY

The sketch below right of Iris foetidissima, *with its decorative seed pods, was made in pencil and watercolour.*

SKETCHBOOK STUDIES

Coloured pencils are useful – but don't forget to take some water when using watersoluble crayons or pencils.

Materials

paper

Paper, in all its variations, is a fascinating subject. There are so many types, from tissue paper, so thin and yet so tough, through to thick and speckled recycled paper. Paper can be glossy or matt, thick or thin.

stretching paper

1 Wet the paper: either soak it in the bath for a few minutes, then shake off surplus water and position it on a board, or place dry paper on the board and wet it all over with a sponge or damp cloth.

2 Stick the damp paper down with a gummed paper strip (not masking tape or sticky tape). Cut the strip into four lengths 12mm (1/2in) longer than each side of the paper. Wet each length with a sponge or damp cloth and stick it down, overlapping the ends and starting with the two longer sides.

what type of paper?

You need a paper that is thick enough to take one or more washes; for sketchbook work, cartridge paper can be drawn on and can take the odd wash of paint, although it is not designed to take too much water. You can buy sketchbooks of watercolour paper, which are more suitable but more expensive.

Both watercolour and cartridge paper can be bought as pads or single sheets; the latter are cheaper and can be cut to size. You can also buy paper in blocks, stuck together on all four sides and with a substantial base; these are ideal for painting away from home as you don't need to stretch the paper beforehand. To remove a sheet from the block, slip a knife around all the edges and lift the sheet away.

It is well worth taking time to get to know different papers and their attributes; art shops usually stock sample sheets and 'pochettes' (manufacturers' packs of a range of papers) you can try. Whatever you choose, be generous when buying paper – people starting out often cramp their style by buying small pads because they are unsure of themselves and unwilling to work freely and boldly.

watercolour paper

There are three basic surfaces of watercolour paper:

- Hot-pressed (HP) is smooth and suitable for more detailed work.

- Cold-pressed (CP) or NOT (not hot-pressed) has a slight 'tooth', the tiny peaks and hollows in the surface, and is ideal for general-purpose painting.

- Rough paper has a more pronounced tooth and is suitable for broad work, such as landscapes.

Watercolour paper is available in different weights. I find the heavier the better, but lightweight papers can always be stretched. To avoid cockling (where the paper shrinks and buckles when washes are applied), it's best to use a paper of 300gsm (140lb) or heavier.

3 Finish with the two shorter sides, then leave the paper to dry naturally. You can place it near a radiator to speed up the drying, but don't use a hairdryer as the gummed strip will tear away from paper.

paints

Paint can be the most confusing part about watercolours; one look at a catalogue or the selection available in a shop is at the same time tempting and alarming. Where to start? The simple answer is to begin with just a few colours, and gradually to build up your own palette of colours as you need them.

types of paint

Watercolour paint is made from pigment, water, gum and glycerine. Some artists make their own paints, but the vast majority buy and use ready-mixed paints, which are available in either tube or pan form. Tube paint is semi-liquid and can be used neat (although it is most often diluted), while pans are dry and require the addition of water before you can paint.

You can buy ready-made selections of pan colours, but a good way to start is to get an empty pan case and fill it with your own selection of colours; this way you won't waste space with colours you may never use or which are unsuitable. Run a brush loaded with clean water over pans before starting, as this helps to soften the paints and make them run more smoothly.

You do not have to stick exclusively to either tubes or pans. If you find that a mixture of these works best for you, go ahead and use it.

The price of each colour varies, depending on the cost of the pigment, and paints are sold in artists' or students' grades. Although artists' paints are more expensive, they are better, as the paint flows more smoothly and the colours are purer.

A basic palette is discussed on pages 14–15, but you need the three basic primary colours to start with – cadmium red, cadmium yellow and ultramarine – plus yellow ochre and burnt sienna as extras.

qualities of paint

No two colours are the same when it comes to how they behave on the paper: some are transparent, some more opaque; some are pretty well permanent – they do not fade when exposed to sunlight over time – and others are fugitive – they need to be protected from light if they are to keep their intensity of colour; some can be washed off the paper without leaving much of a mark, while others stain the paper and are thus impossible to remove. Manufacturers have different methods of grading each of these qualities, but most people find these out for themselves as they go along.

WATERCOLOUR TUBE PAINTS

7

brushes

Getting used to working with a brush is essential. Whatever the subject you want to paint, it is your most important tool. Remember, if you can draw with a pencil, you can draw with a brush.

Look in any art shop or catalogue, and you'll see an overwhelming number of brushes to choose from. I mainly use no more than three round brushes: from smallest to largest a No. 4 or No. 6, a No. 8 and a No. 12. The No. 12 will do almost anything as it is firm and flexible, holds plenty of water and has a good point; start with this size, even if it seems to be large when you begin.

The best material for watercolour brushes is sable, but this is expensive; there are many good synthetic substitutes and sable/synthetic blends. When buying brushes, check the point, as you should be able to use this as well as the body of the bristles. I use the smaller sizes for very fine details, but be warned, using very small sizes can hinder your progress if you want to achieve fresh, clean and clear watercolours. So take courage and work with the large brush almost exclusively at first, and reserve the smaller sizes for later.

Practise making as many sorts of strokes as you can, from long, flowing marks to short, dabbing ones – time spent doing this is invaluable. Draw with your brushes, and try to become as used to working with a brush as with a pencil.

VERSATILE BRUSHES: NOS 12, 8 AND 4
The brushstrokes at top show the different kinds of strokes you can achieve with just one brush, the No. 12 round, in addition to laying all kinds of washes.

other equipment

There are a few other pieces of equipment, some of which are essential, that are useful either to save time or to achieve certain effects.

drawing board
It is important to have the right drawing board for the task. My main board is a lightweight 'rigid' wooden board measuring a generous 380 x 510mm (15 x 20in). Hardware stores usually cut board to size.

palettes
Some form of a clean, white palette is essential. A white plate works well for tubes. Squeeze each colour around the outside, and use the centre for mixing.

useful accessories
- Two water pots: jam jars will do, but plastic ones won't break.
- Grades B and 2B pencils are best for sketching and preliminary drawing. Keep them sharp.
- A knife, scalpel or pencil sharpener.
- A soft eraser.
- A ruler for measuring and judging angles.
- Masking fluid.
- A natural sponge for dampening paper: the flow is better than that from artificial sponges.
- Kitchen paper or clean cloths or rags for blotting off paint or mopping up spills.
- A hairdryer dries washes quickly, but is not vital.

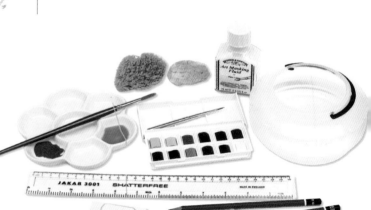

Techniques
brushstrokes

It's now time to get down to work and practise using the brush to draw flowers and leaves. Ideally you should work from a flower and some leaves in front of you; alternatively, follow the examples on this page.

Either way, try to work life-size, and don't worry if you make a mistake or a blot, just concentrate on getting the shape in one go. Use a No. 12 round brush except where specified. For inspiration, look at the leaves on trees and imagine how you could represent each of the types, from pine needles and the narrow leaves of a willow, to apple or oak leaves; each requires a different kind of mark.

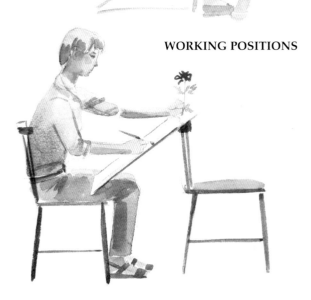

WORKING POSITIONS

Alternate between brushes as you practise painting leaves. I used a No. 4 round to create very thin leaves, using the same method of a single brushstroke for each leaf.

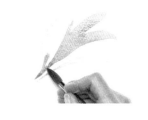

When switching to a larger brush for bigger shapes, don't forget that you can leave a white line between the colours so they don't run; but again try to be bold with your brushstrokes, getting them right each time.

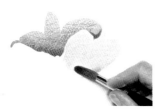

To give the appearance of a mass of grassy leaves, you may need to blend together different, single, short strokes. Try not to hesitate, and resist the temptation to touch up the results. If it doesn't work, start again.

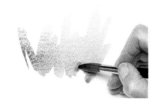

Putting a second wash over a dry one. Note the hold of the brush, which is loose and quite unlike the standard pencil grip, and which helps when making short, dabbing strokes like this.

Here I use a No. 4 brush to make fine, grass-like lines. There should be no stopping and starting, but continuous sweeps of the brush.

washes

A wash is basically any layer of colour on the paper, large or small, applied with a brush or sometimes a sponge. All watercolour paintings are made up of a number of washes, either laid side by side or applied in overlapping layers. The two washes most used are flat washes, where the paint is laid down in as even a colour as possible, and graduated washes, where deliberate variations on the flat colour are created. All watercolours dry about 50 per cent lighter than when applied.

flat wash

Painting even a simple wash of colour needs thought and preparation, and there are several basic things you should do before you put brush to paper. First, always mix plenty of colour – more than you think you will need – and have a large container for water. Test the colour on scrap paper. Set the drawing board at a slight angle as gravity will help the wash to flow, but not so much that you lose control of the wash when it is applied, and make sure the No. 12 round brush is fully loaded.

Starting from the top, apply an even stroke across the paper, then repeat this a little lower so that the top of the new stroke joins on to the bottom of the top one. Continue down the paper, and don't go back and touch up the wash in any way. Allow to dry.

graduated wash

Painting a graduated wash, one that gets lighter as you progress down the paper, is a matter of adding clean water to the layers of the original wash colour, using a similar technique as for a flat wash. You can also use different colours in a graduated wash, which is particularly useful for painting flowers and leaves where a smooth transition of colours is needed. The main thing to bear in mind is that you must use plenty of loose, fluid colours if you want to achieve a good result.

Mix up plenty of colour and start as for a flat wash. As you work down the paper with even strokes, add a little clean water to the brush; work quickly, so that the paint has no chance of drying on the paper between the strokes.

For a colour-graduated wash, instead of adding clean water, apply a different colour; practice and experience will enable you to make a smooth blend and transition.

wet-into-wet and wet-on-dry washes

Once you have learned how to apply single layers of washes, you have the choice of working wet into wet or wet on dry. The former technique is what makes watercolours unique as the results are unpredictable: this unpredictability of wet into wet is all part of the process. Mistakes, runs and blotches can sometimes be incorporated into a painting, and keeping one eye open for such happy accidents keeps you on your toes.

It is fun to experiment with applying wet colours onto other wet ones: some colours react against each other, pushing the paint away, and others mix gently to give soft effects. Certain colours, such as ultramarine and burnt sienna, separate when they are mixed and create a granular texture on the paper.

Working wet on dry is more straightforward, as long as you remember to work in layers from the lightest colours to the darkest ones. Always let each wash dry completely before you paint over it, or you will find that the new wash picks up the underneath colour and runs and bleeds, making the edges indistinct and fuzzy.

Here the colour blends smoothly because the wash underneath is still wet when the new colour is applied. Use a paper towel to blot off paint for lighter areas.

Wet-into-wet blending is useful for creating shadow colours on a flower. Allow the colours to mix on the paper to produce a vibrant effect.

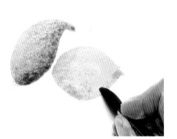

These light green leaves were overpainted with a darker green and a touch of red-brown while still wet. You have to work quite quickly to achieve this effect successfully.

In this variation on wet into wet, the petal shape was initially painted with clean water; the pink was just touched in on the petal tips and ran into the water. When this had dried completely, the green centre was painted in the same way.

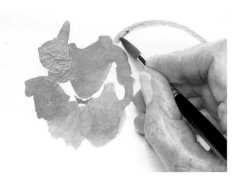

The red flower and green stem were painted on a completely dry yellow wash – wet on dry – giving sharp edges to the colours. The first wash must dry thoroughly: this could take an hour or so, depending on the room temperature, unless you use a hairdryer to dry the first wash.

flower structures

Knowing the basic structure of a flower or plant, although not absolutely necessary for most purposes, will help you get to know its character – whether it has five or six leaves, whether the leaves are alternate or opposing, and their shape.

The painting of a tulip here shows the principal parts of a flower: the petals, stamens and pistil, and anther, stem and leaves.

As an artist it is vital for you to know the basic shape of the flower you intend to paint – even if you do not know its name, being able to identify its simplified shape and characteristics will help you enormously when you come to draw or paint it.

patterns

Nature creates patterns in the arrangements of how petals and leaves grow – they may be two-coloured or variegated, and they may overlap; geranium and cyclamen have distinctive patterns on each individual leaf, for instance.

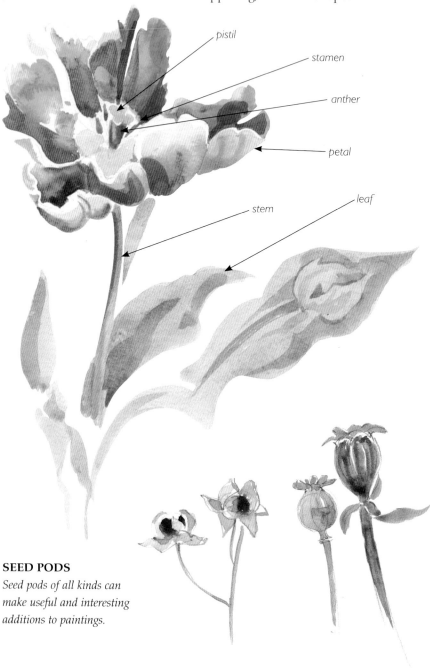

pistil

stamen

anther

petal

stem

leaf

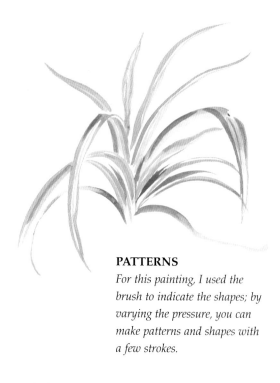

PATTERNS

For this painting, I used the brush to indicate the shapes; by varying the pressure, you can make patterns and shapes with a few strokes.

SEED PODS

Seed pods of all kinds can make useful and interesting additions to paintings.

leaves and stems

When drawing or painting leaves, look for their character: are they glossy and dark or soft and pale? Are they single or in groups, variegated or plain? The edges can be serrated or smooth, while some leaves, like the iris, are sword-shaped.

Leaves of grass can be described with swift, sure strokes of the brush, but leaves that twist and curl are like ribbons – practise and let the brush do the work for you!

Try to keep to light, medium and dark shades, and introduce blues and reds to amend the colours if necessary.

SHINY LEAVES

To paint the shine that appears on certain leaves, such as those of camellias or holly, paint an initial light blue-grey wash and allow it to dry before you apply the green.

CROPS AND GRASSES

Practise drawing the fine lines of crops and grasses with brushes that have a good point.

BACKS AND FRONTS

Leaves which present both sides to the observer, like the variegated leaf above, need to be drawn and painted carefully. Look closely, and draw what you see.

STEMS

Some stems are strong and thick, others slender, and some are hairy. You don't need to put in every detail, but note the dark and light sides, and try to use a single, firm brushstroke.

LEAVES WITH VEINS

This ivy leaf shown is half painted – the first wash of light green represents the veins. The negative shapes of the darker green, applied after the first wash has dried, define the pattern of the veins.

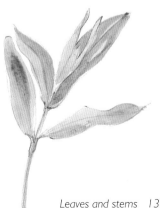

LEAVES AND STEMS

Leaves and stems must join together accurately.

colour

The basics of understanding colour and colour mixing are dealt with thoroughly in many books, so I shall concentrate here on the immediate uses of colour in flower painting.

mood and atmosphere

Some colours are described as 'warm', for instance red, and some as 'cool', such as blue, reflecting the emotions they arouse in the viewer. But there can be differences in colours, with yellows, greys and greens, among others, having a wide spectrum from warm to cool. Experiment to see how you can make warm or cool greys from the different reds and blues in your palette.

You can use the temperature of colours to set the mood and atmosphere of a painting. The most obvious way is to associate each colour with the time of day, from early morning to late evening or night; but you can also use the seasons in the same manner – for instance, spring with fresh, bright, coolish colours and summer with warmer versions of the same greens and yellows, while autumnal reds and browns tend to warm, and winter has cool blues and greys.

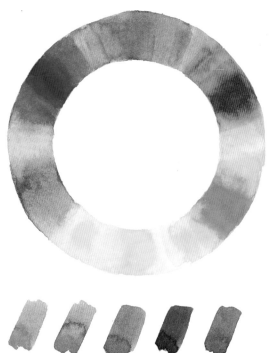

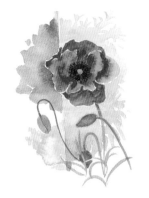

PRIMARY COLOURS

I used only primary colours in this little painting of a poppy – cadmium red, cadmium yellow and ultramarine – to make a harmonious composition.

SECONDARY COLOURS

Here, love-in-a-mist (Nigella) is paired with an orange wallflower. Cobalt blue is one of the cooler blues, a primary which combines well with the warm cadmium orange, a secondary colour.

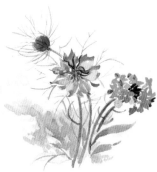

basic palette

It is vital to develop a basic palette of colours for your subject; you can always add to this when necessary. One of the main reasons for having just a few colours is that doing so means that with practice you will become adept at mixing and thus understanding how colours combine and work together, in nature and on paper.

My basic palette consists of ultramarine, cadmium red, magenta, yellow ochre, burnt sienna, cadmium yellow and a green mixed from cadmium yellow and ultramarine. Make a colour chart for yourself, using the basic palette to become familiar with the colours and the many hues that can be achieved through different combinations and concentrations. Generally in painting, it is the tonal values of a colour that are important – the relationships of each colour to its neighbour – and the local colour, the actual colour of an object, less so.

SATURATED COLOUR

The darkest version of ultramarine, on the left of the bar, is the saturated colour, with no water used to dilute it. You can see how gradually diluting the pure colour changes the tint and makes it lighter.

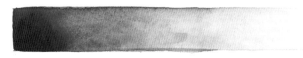

natural greens

Most leaves and stems are green, so it is an important colour to understand when painting flowers – you will need to have a range from light to dark, and need to know how to make greens. I prefer to mix my own, and try to stick to a light, medium and dark green, with the addition of blues or reds as required: the light green is not a watered-down version of the others – light does not mean watery.

Among readily available greens are sap green, a useful, bright and cheerful green, but liable to fade; olive green, a flat but pleasant green; viridian, a light and clear emerald green that is useful for mixing with earth colours; and Hooker's green, also useful when mixed with earth colours. There are all sorts of mixes you can make up, so experiment by varying the colours you use.

earth colours

The earth colours – siennas, ochres and umbers – are basic to painting natural subjects. While they should be essential in your palette, be careful how you use them, as they can muddy flower tints when overemployed.

Of the basic earth colours, raw sienna is a beautiful transparent yellow; yellow ochre is similar, but more opaque; raw umber is a clear brown with a touch of green; burnt sienna, a reddish brown, is very useful for combining with blues to make greys, or with green-blues to make dark greens; and burnt umber is a darker red-brown that has similar uses to burnt sienna.

WARM AND COOL

A purple cornflower (made by mixing Winsor violet and ultramarine) is paired here with wild flowers, the ox-eye daisy and charlock. The warmth of the purple and the background contrasts well with the cool Winsor yellow used for the charlock.

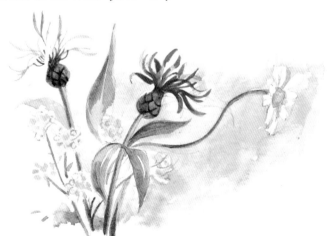

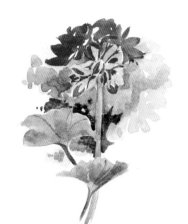

GREENS

The two top greens here, olive green and sap green, are ready-made shades; all the others are mixes. Second row: ultramarine and cadmium yellow, ultramarine and yellow ochre, and Prussian blue and Winsor yellow. Bottom row: Prussian blue and burnt sienna, Winsor yellow and olive green, and cerulean blue and Winsor yellow.

RED AND GREEN

The primary red and its complementary colour green always work well together. The geranium here is painted with magenta, while the green is a mixture of sap green and burnt sienna.

EARTHS

Top row: yellow ochre; raw umber; burnt sienna Bottom row: burnt umber; raw sienna

light and shade

Light helps us to see our subject in the first place, and light combined with shade helps to define the form or shape. Light and shade also produce other effects, such as drama and variations in colour.

Colour can change under different lighting conditions, and you can affect this when painting indoors by using artificial light to your advantage. For example, you can direct light onto a particular area you wish to highlight, and make silhouettes or reverse flowers out of a background. Light and shade also create patterns, and can be used to promote abstract shapes. I find it helpful to work in three tones – light, medium and dark – and to constantly remind myself to try to see light to dark and dark to light.

This bromeliad has been worked in an abstract way; the light and shade make interesting patterns and shapes without the use of direct light.

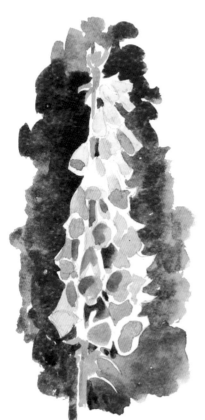

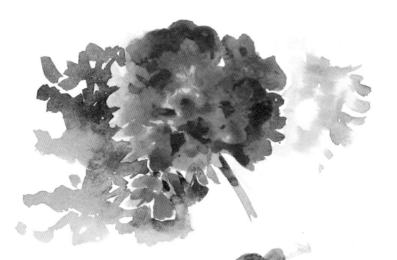

The sunlight behind this pelargonium throws it into shadow. The dark tones suggest form and depth, achieved with minimal detail.

Although there is a fair amount of shade on this white foxglove dramatically lit by sunshine, the flower is obviously white. The clear silhouette helps to throw it into relief from the background.

The dark areas on these leaves help to define their shape and create form.

tone

Whatever you are painting, it is easy to be seduced by the idea of the flower shape and to forget all the colours and tones that make it so attractive. When the sun is shining onto a flower it is possible to see the lights and darks, but where there is no strong light you have to rely on the actual colour that you see – for example, a light-coloured flower can be contrasted with a darker background of leaves. If you are painting a white flower, using a darker background makes it possible to define the edges.

I often look for the darkest tone in a painting, paint it in early on and use it as the basis for the rest of the work. This is pretty well the opposite of the classic watercolour technique of working from light to dark, but it need only be employed over a small area.

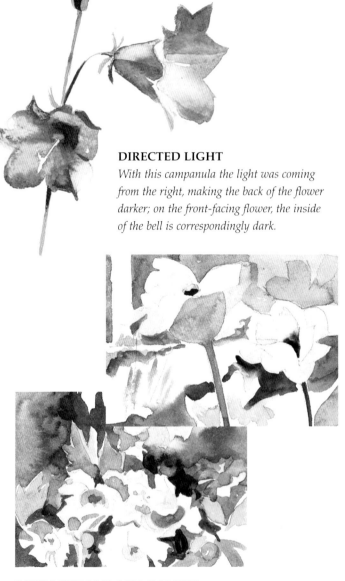

DIRECTED LIGHT

With this campanula the light was coming from the right, making the back of the flower darker; on the front-facing flower, the inside of the bell is correspondingly dark.

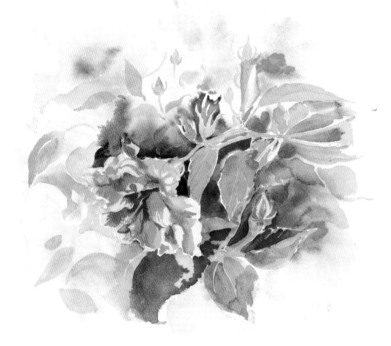

USING BACKGROUND

This hibiscus was painted in a greenhouse with no direct light on the flower – the painting relied on the tonal values of the dark colours behind the subject. Lighter greens provide a sense of distance.

MONOCHROME AND COLOUR

Rough, monochrome, thumbnail sketches such as these give some idea of tonal values; they don't take too long, and save time when you start to work in colour. I used Payne's grey for the tonal studies. These small sketches are also useful as compositional aids, as they help to clear the mind of extraneous detail.

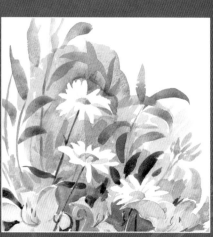

The Flowers

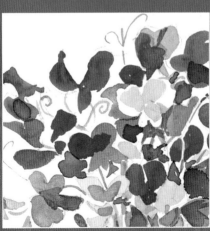

Agapanthus

Also known as the African blue lily, agapanthus is a striking plant, not only for its colour and size, but also for its character. It has strap-like foliage and handsome flowers of various shades of blue, white, pink and purple. It is large (over 1m/3ft high) and a delight to paint.

Colour palette

French ultramarine sap green permanent rose yellow ochre

➤ *This pot of white agapanthus provided a marvellous subject to paint while sitting in the sun!*

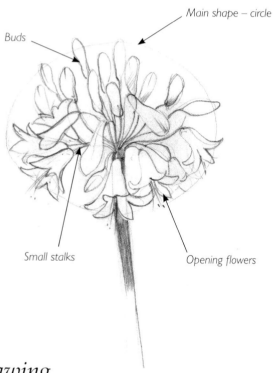

Main shape – circle

Buds

Small stalks

Opening flowers

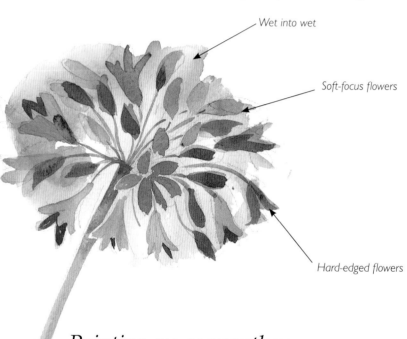

Wet into wet

Soft-focus flowers

Hard-edged flowers

Drawing

First, make an overall shape – a dome or a circle – and work into that with individual flowers and buds. The flowers are bell-shaped and held on short stalks from the stem. Make the stem strong, as this can be a tall plant.

Tip: Keep your water clean, and don't go on painting with dirty water; use two pots of water if necessary.

Painting an agapanthus

1 Draw the main shape as a dome or circle, then the individual flowers or buds.

2 Use a sponge to paint over the flower area with clean water.

3 Drop in a light mix of French ultramarine and permanent rose.

4 When this wash is either dry or still damp, paint the flowers or buds with a darker mix of ultramarine and rose.

5 Make a mix of sap green and yellow ochre, and use this to paint the stem and small stalks.

6 If required, add some more detail and darker tones.

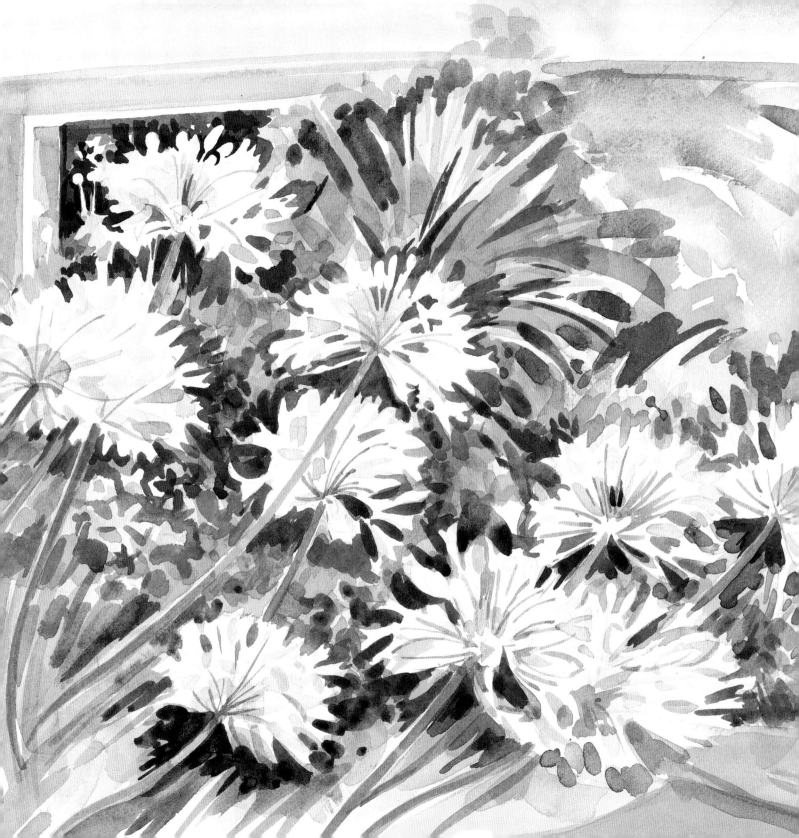

Amaryllis

Amaryllis take your breath away: you can watch them coming out day by day until the whole flower appears and you are mesmerized by their beauty. They cheer you up on cold winter mornings and are marvellous to paint – flamboyant and striking in red, pink or white.

Colour palette

cadmium red cadmium yellow brown madder

sap green yellow ochre

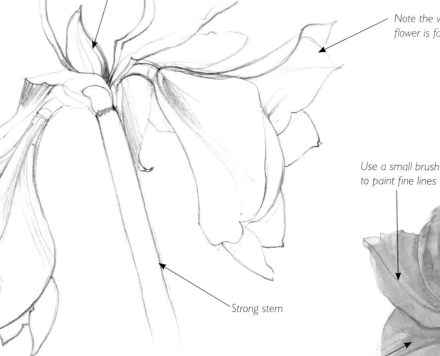

New bud

Note the way the flower is facing

Strong stem

Use a small brush to paint fine lines

Second wash

Trumpet shape

Deeper colour

First wash

Painting an amaryllis

1 Be aware of the direction of light, which gives the flower shape and form.

2 Draw carefully before noting the spaces between petals.

3 Using a large (No. 12) brush, paint the flower using light, medium and dark tones of colour.

4 Put in any detail at the end.

5 Check the tonal values and increase them if necessary.

6 Paint the stamens and pistil; alternatively, draw them lightly with a pencil.

➤ *As here, I paint amaryllis life-size; but, like Georgia O'Keeffe, you could paint them much larger. You can always change the picture size and format: flowers often call for long, narrow picture shapes, so try it.*

Drawing

The amaryllis is trumpet-shaped and large. Draw it as it emerges, and draw it life size from every angle; see how the flower joins the stem, and practise getting the front view right.

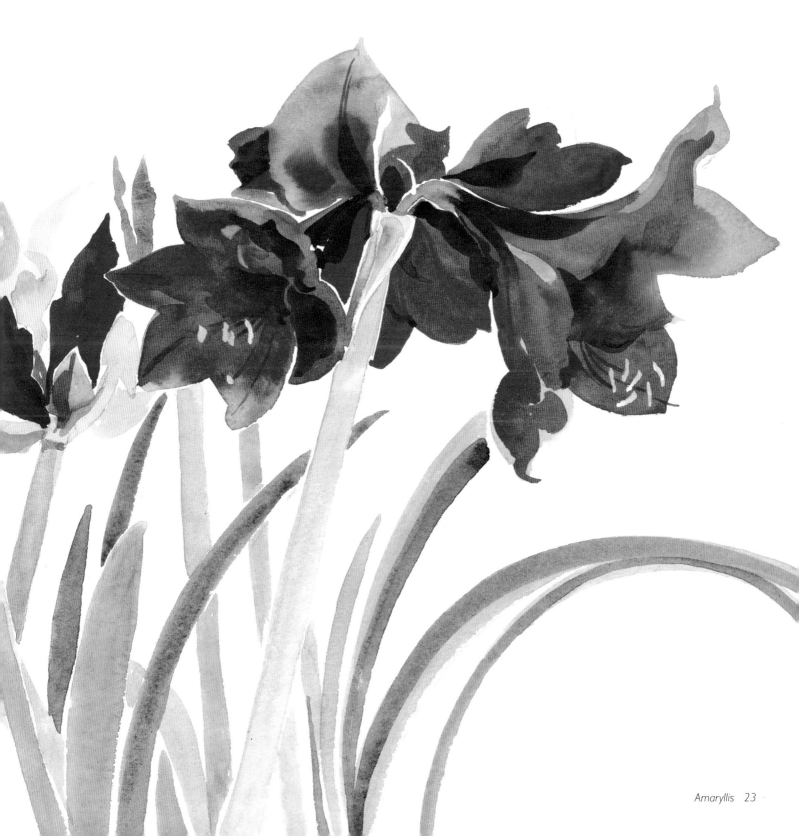

Anemones

The rich, jewel-like colours of anenomes have always attracted me; the lovely, striking reds, purples and magentas, combined with a simple shape, make them ideal flowers to paint. The leaves are cut and divided, giving the appearance of halos around the flower.

Colour palette

Winsor violet magenta alizarin crimson carmine

sap green yellow ochre Prussian blue burnt sienna

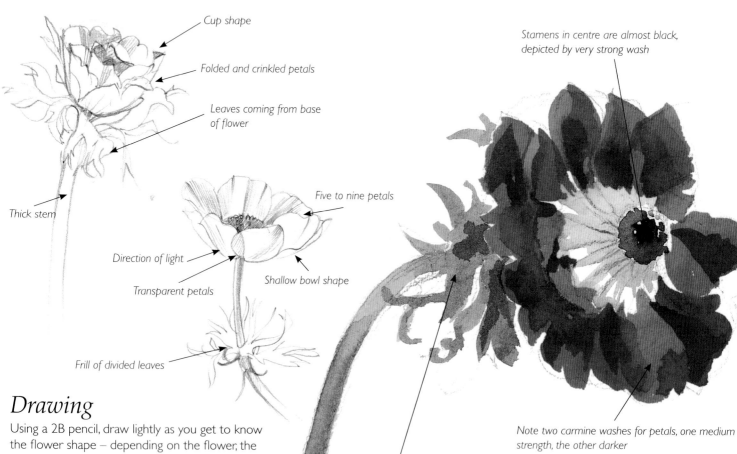

Cup shape

Folded and crinkled petals

Leaves coming from base of flower

Thick stem

Five to nine petals

Direction of light

Shallow bowl shape

Transparent petals

Frill of divided leaves

Stamens in centre are almost black, depicted by very strong wash

Note two carmine washes for petals, one medium strength, the other darker

Divided leaves come from base of thick stem and are of varying shades of green

Drawing

Using a 2B pencil, draw lightly as you get to know the flower shape – depending on the flower; the shape can vary between a shallow bowl, a cup and a disc. Note the number of petals, and draw the detail last. Finally, add in the centre and the leaves and stems. Always check for errors and make any corrections if required.

Painting anemones

1 Draw the flowers using a light pencil line, referring to your studies and drawings; draw guidelines that can be erased later.

2 Using a No. 12 round brush, paint the first wash of the flowers using a medium wash of carmine or Winsor violet and lots of water. Allow to dry.

3 Paint shadows using a darker mix of the same colour, softening the edges with water on a clean brush.

4 Paint the shadows in the centre using a mix of Prussian blue and burnt sienna.

5 For the stems and leaves use varying mixes of sap green and yellow ochre; add some magenta for any pink stems.

6 Mix Prussian blue and alizarin crimson to paint the stamens with a No. 4 round brush and the centre of the flowers with a No. 8 round brush.

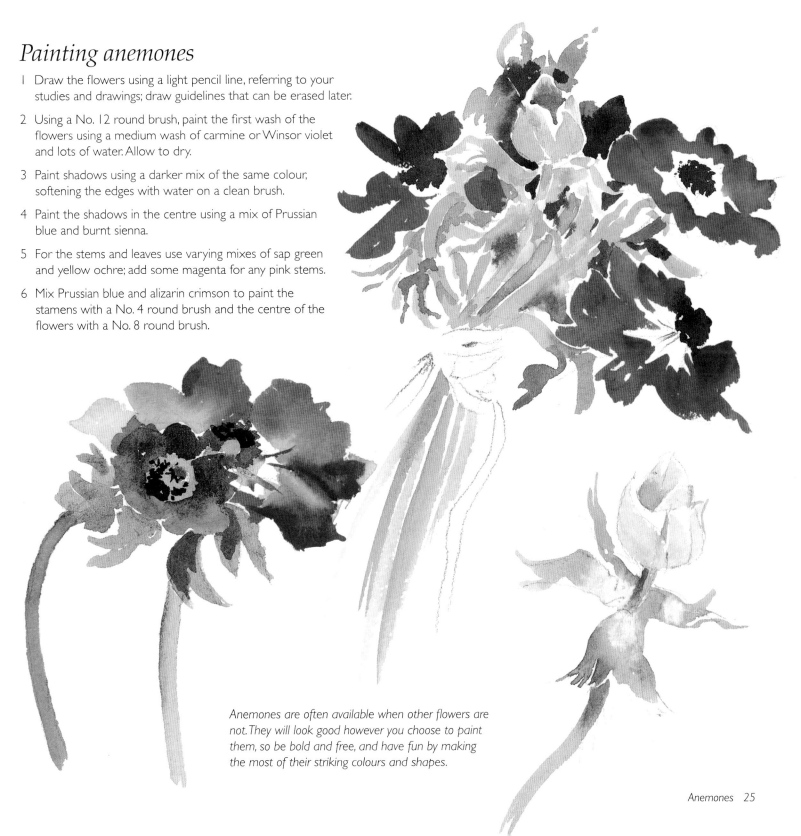

Anemones are often available when other flowers are not. They will look good however you choose to paint them, so be bold and free, and have fun by making the most of their striking colours and shapes.

Begonias

Although begonias originate in tropical forests, the ones we grow are mostly for summer bedding or are pot plants. They have numerous flowers, which can be single or double, some with beautifully marked lopsided leaves. Begonias are bright and colourful, good for hanging baskets.

Colour palette

scarlet lake cadmium lemon sap green

olive green French ultramarine

Drawing

This particular begonia has very decorative leaves but very small pink flowers, so I chose to draw the leaf using a sharp pencil on hot-pressed (HP) paper.

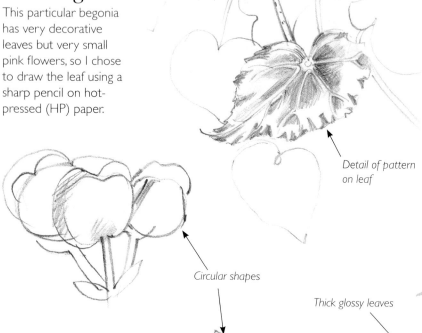

Detail of pattern on leaf

Circular shapes

Painting begonias

1 Draw the single or double flowers carefully.

2 Paint over the flower area with a wash of scarlet lake.

3 Blend in sap green and cadmium lemon on the leaves.

4 Strengthen the wash on the flowers to help delineate the petals.

5 Paint the stems with a pale wash of olive green and sap green.

6 Strengthen the green by adding more pigment and a touch of French ultramarine.

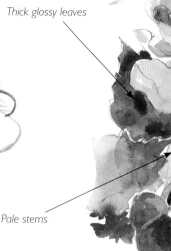

Thick glossy leaves

Pale stems

Pencil details added

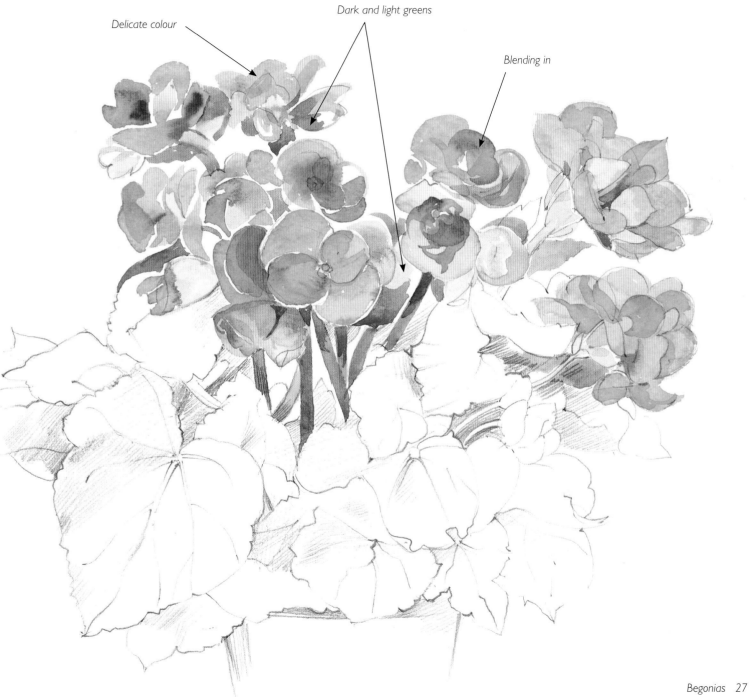

This semi-tuberous begonia is a pot plant and has small spiralling petals on the flowers. It can be red, pink, orange or white, and appears in spring to cheer you up.

Dark and light greens

Delicate colour

Blending in

Blossoms

The first spring blossom comes out in February, and what a welcome sight it is! Once it is followed by other blossoms, you know that spring is on its way. The flowers usually appear first, and when they fade the leaves take over. Direct painting with a brush is often the best way to approach blossoms.

Colour palette

permanent rose raw umber Winsor yellow French ultramarine

Painting blossoms

1 Draw an indication of positioning with a pencil.

2 Load the brush fairly full with a pale wash of permanent rose, and paint the petal and flower shapes confidently and without hesitation.

3 Link the blooms together by painting the twigs and branches with raw umber; you may need to stand and sweep with your whole arm to do this.

4 Put in any shadow on the petals with a grey made by a mix of permanent rose, Winsor yellow and French ultramarine.

5 Add details such as stamens by either painting or drawing them.

No leaves

Open bowl shape

Character of the small branch is important

Delicate detail in centre

Drawing

Draw carefully to fix the shape of the flower, which is often a simple cup or bowl shape; the leaves usually follow the blossom. The drawing here is of forsythia, which is a brilliant yellow.

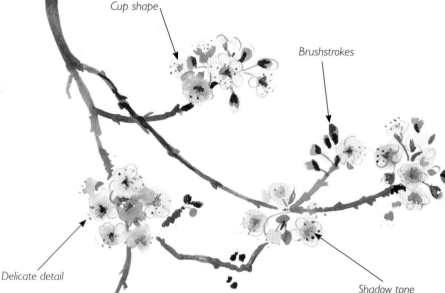

Cup shape

Brushstrokes

Delicate detail

Shadow tone

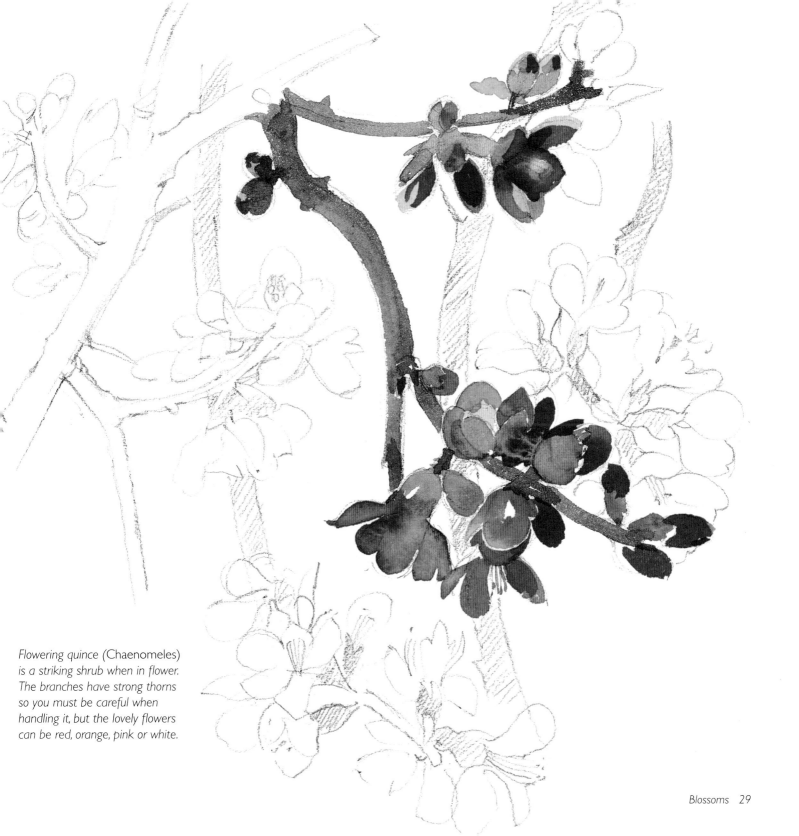

Flowering quince (Chaenomeles) is a striking shrub when in flower. The branches have strong thorns so you must be careful when handling it, but the lovely flowers can be red, orange, pink or white.

Bluebells

The blueness in a bluebell wood is truly amazing – each individual flower contributes to the overall colour, which, when combined with the soft spring green of trees, makes the sight unforgettable. When painting single bluebells, the perfect bell shapes of the flowers are fascinating.

Colour palette

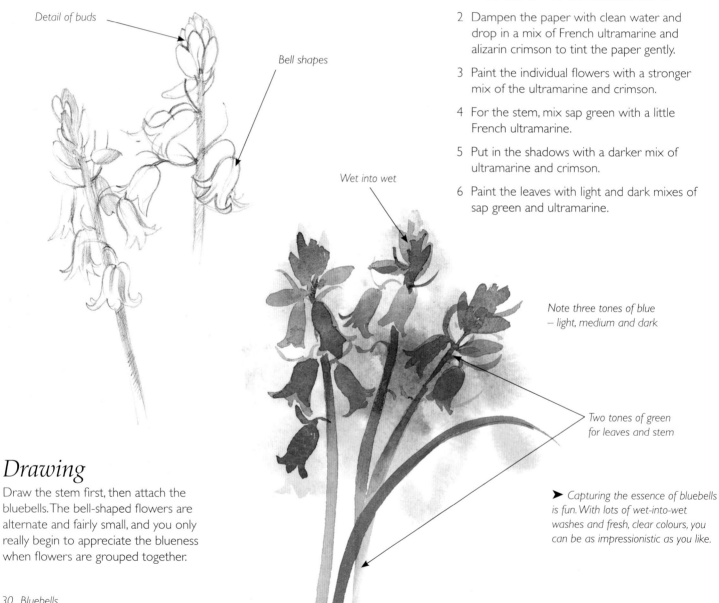

French ultramarine alizarin crimson sap green

Painting bluebells

1 Draw one or two bluebells and leaves.

2 Dampen the paper with clean water and drop in a mix of French ultramarine and alizarin crimson to tint the paper gently.

3 Paint the individual flowers with a stronger mix of the ultramarine and crimson.

4 For the stem, mix sap green with a little French ultramarine.

5 Put in the shadows with a darker mix of ultramarine and crimson.

6 Paint the leaves with light and dark mixes of sap green and ultramarine.

Detail of buds

Bell shapes

Wet into wet

Note three tones of blue – light, medium and dark

Two tones of green for leaves and stem

➤ *Capturing the essence of bluebells is fun. With lots of wet-into-wet washes and fresh, clear colours, you can be as impressionistic as you like.*

Drawing

Draw the stem first, then attach the bluebells. The bell-shaped flowers are alternate and fairly small, and you only really begin to appreciate the blueness when flowers are grouped together.

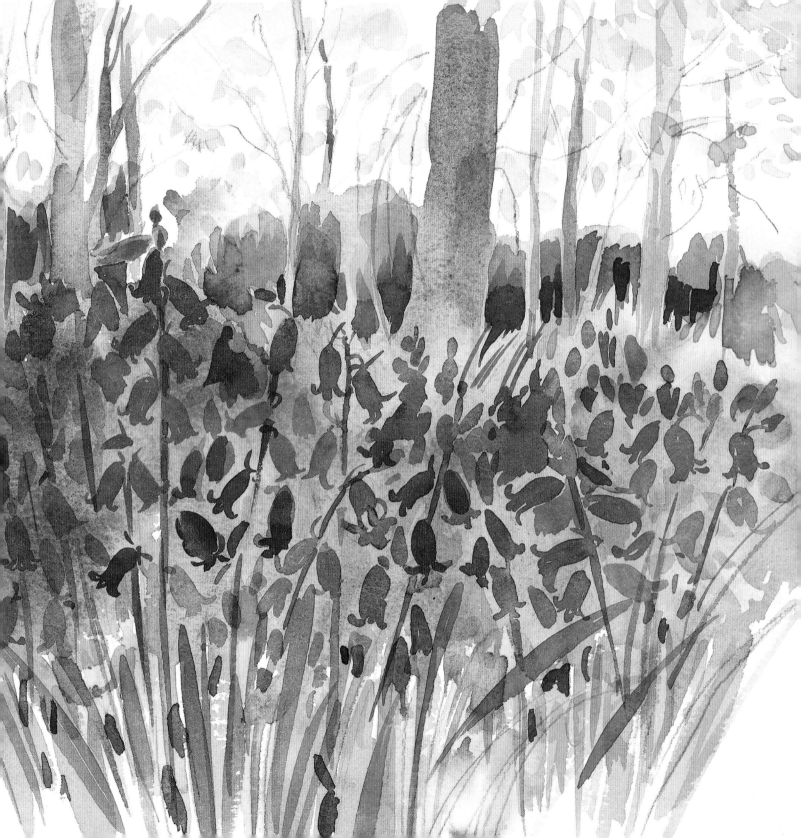

Bougainvilleas

A Mediterranean shrub, bougainvillea's brilliant bracts and colourful displays are a delight to see. What appear to be flowers are actually not – they are colourful bracts, and the flowers themselves are insignificant. Bougainvillea trails and grows over balconies and around doors, and scrambles over buildings with unsurpassed brilliance.

Colour palette

 magenta sap green burnt sienna

 French ultramarine raw umber

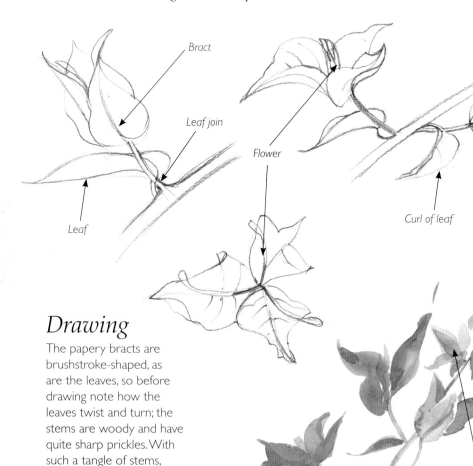

Bract

Leaf join

Flower

Leaf

Curl of leaf

Dark tone

Light tone

Medium tone

Drawing

The papery bracts are brushstroke-shaped, as are the leaves, so before drawing note how the leaves twist and turn; the stems are woody and have quite sharp prickles. With such a tangle of stems, leaves and bracts it can be difficult to know where to start; the three leaf bracts fold around the tiny flowers and are a similar colour.

Coloured bracts

Brushstrokes

Painting a bougainvillea

1 Draw with a brush if you feel confident enough, otherwise indicate the directions with a pencil.

2 Using a No. 8 round brush, paint the bracts with a medium-toned magenta wash.

3 Mix a medium-toned green from sap green and burnt sienna, and paint the leaves quite freely, using the brush to make the shapes.

4 Paint the tones on the bracts with a darker shade of magenta.

5 Add a little French ultramarine to the green mix and paint the variations on the leaves.

6 After painting the stem with raw umber, use a No. 4 round brush to attach the leaves and bracts to it.

7 Paint the leaves with a mix of sap green and ultramarine.

8 Paint in any further details.

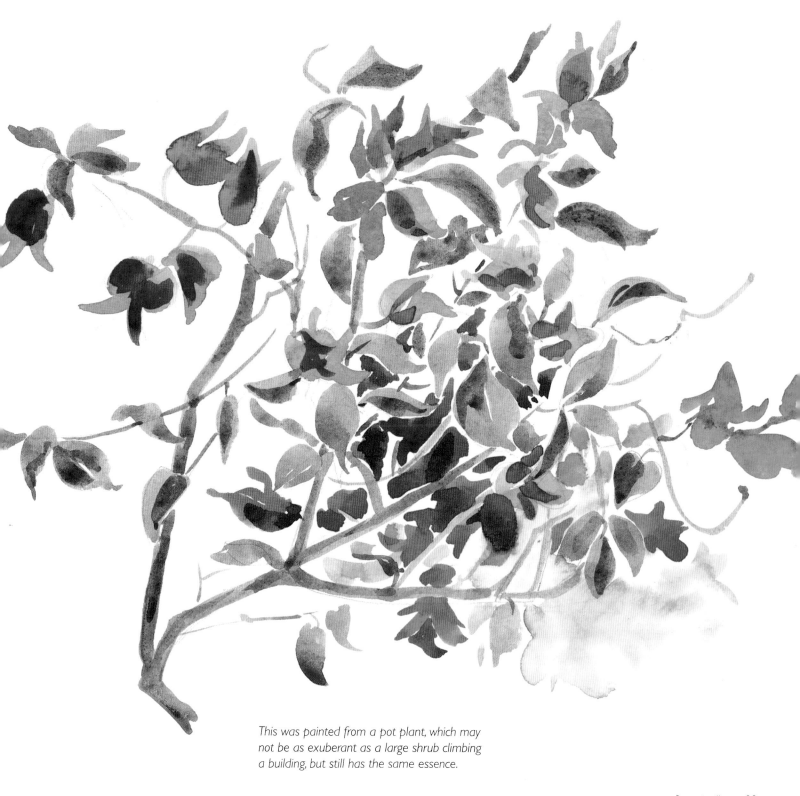

This was painted from a pot plant, which may
not be as exuberant as a large shrub climbing
a building, but still has the same essence.

Buttercups

As their name suggests, buttercups are cup-shaped; their shiny, yellow petals are loved by children. To see a field of bright yellow buttercups in spring is an experience not to be missed. They are classed as weeds by some gardeners, but there are garden varieties that are very pretty.

Colour palette

cadmium yellow cadmium orange olive green

Larger than actual flower

Drawing

Draw the simple cup shape then divide this into petals, which are small and delicate and quite shiny. The stem is long and thin, and the plant has divided leaves. Draw the buttercup from all angles and include any buds.

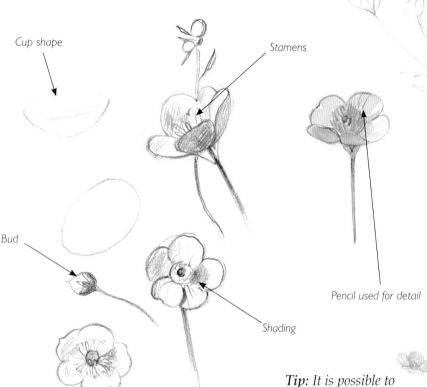

Cup shape

Bud

Stamens

Shading

Pencil used for detail

Sap green used as shading

Cadmium yellow and orange used for stamens

Painting buttercups

1 Draw the flowers somewhat larger than life.

2 Paint the petals with a light/medium wash of cadmium yellow.

3 When this wash is dry, paint the stamens with a darker yellow mix using a little cadmium orange.

4 Paint the small centre using olive green.

5 Then paint the darker side and shadows using cadmium yellow and olive green.

6 Use a No. 4 round brush to paint the stems with olive green.

Tip: *It is possible to substitute other yellows for cadmium yellow; aureolin has a greenish tint.*

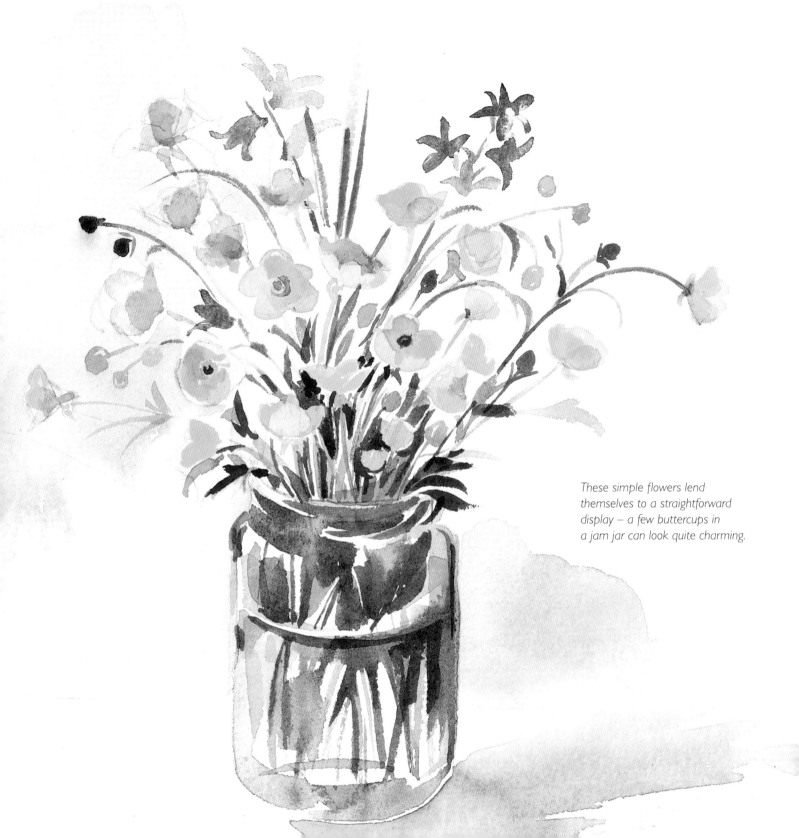

These simple flowers lend themselves to a straightforward display – a few buttercups in a jam jar can look quite charming.

Camellias

These lovely flowers bring a splash of colour to late winter and early spring, although the shiny leaves can pose a problem for the watercolourist and need practice. The flowers can be white, pink or red; some are fairly large, while others are small, and some can be fragrant.

Colour palette

permanent rose French ultramarine Naples yellow

yellow ochre aureolin

Many stamens with anthers

Overlapping petals

Draw curling leaves accurately

Disc or sphere shape

Blue underwash

Darker tone

Medium green

Light veins

Tip: *Be aware of the source of light, which can help to define the shape of the flower.*

Drawing

This camellia is basically a dish or shallow bowl shape; draw this first, then the stamen area, and then the separate petals. Double camellias have many petals, rather like roses, and care has to be taken when drawing them.

Sepal

Note calyx

Pale stamens

Painting a camellia

1 Draw the camellia with a 2B pencil.

2 Using a No. 8 round brush, paint the stamens with a pale wash of Naples yellow and leave to dry.

3 Paint the petals with a light wash of permanent rose.

4 While this wash is wet, use a mixture of permanent rose and French ultramarine to paint the darker areas.

5 Use aureolin to paint the stamen heads.

6 Define the details with yellow ochre.

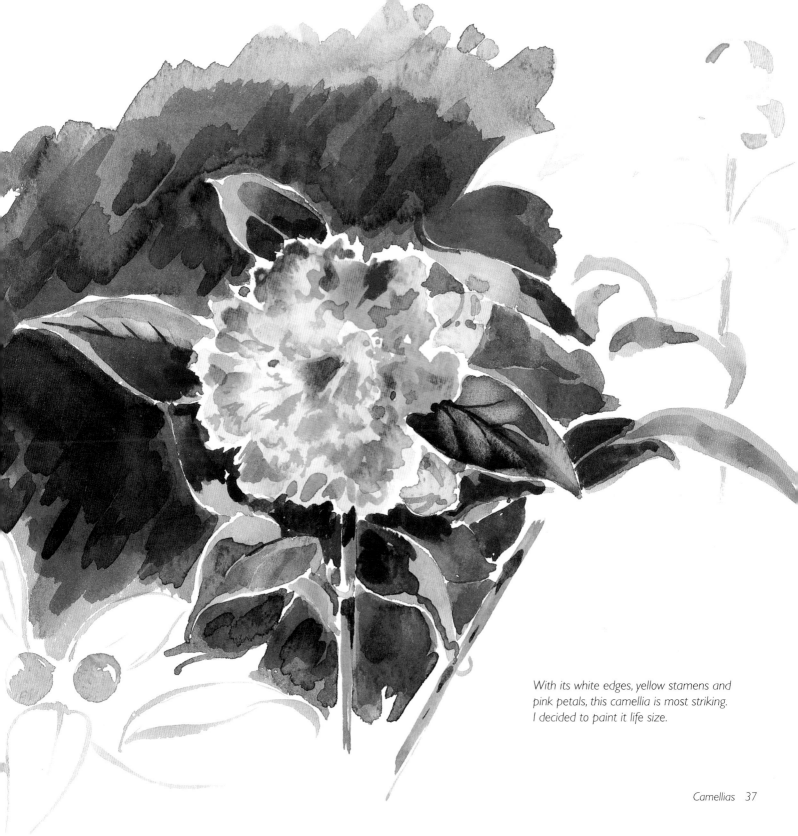

With its white edges, yellow stamens and pink petals, this camellia is most striking. I decided to paint it life size.

Cardoons

The beautiful and statuesque cardoon, well-established in many gardens, always receives admiring looks and is a pleasure to paint. Because it is so tall, you either have to stand to paint it or move some distance away. It grows well alongside hollyhocks, whose pale yellow petals complement the purple cardoon heads.

Colour palette

Winsor violet burnt umber French ultramarine Winsor yellow

sap green brown madder burnt sienna

Drawing

The cardoon is a thistle or goblet shape, with the flower appearing at the top. Try to draw the shape while being aware of the scales – and draw lightly with a 2B pencil so that the pencil lines will hardly show. Don't forget to make drawings of the leaves.

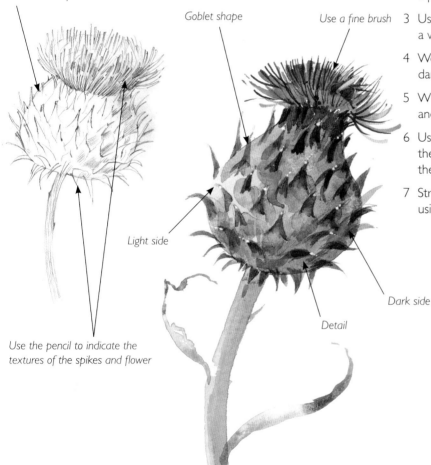

Note the shape

Goblet shape

Use a fine brush

Light side

Dark side

Detail

Use the pencil to indicate the textures of the spikes and flower

Painting a cardoon

1 Draw the cardoon, taking care to get the shapes right.

2 With the light direction in mind, paint the cardoon in a pale mix of French ultramarine and burnt umber.

3 Using a mix of ultramarine and Winsor yellow, float a wash over the top of the first one.

4 Working wet into wet, paint the dark side with a darker mix of the same colours.

5 When this is dry, paint the scales using brown madder and Winsor violet.

6 Using fine, small strokes of a No. 4 round brush, paint the top with violet, with perhaps some ultramarine at the base.

7 Strengthen the colours if necessary, and paint the stem using sap green and burnt sienna.

➤ *This was painted in front of the subject, and I started with the heads, stems and leaves, followed by the sky and other foliage. It is important to achieve the broad effect first, as detail is an easy part of the painting – in fact, the spikes were left until last.*

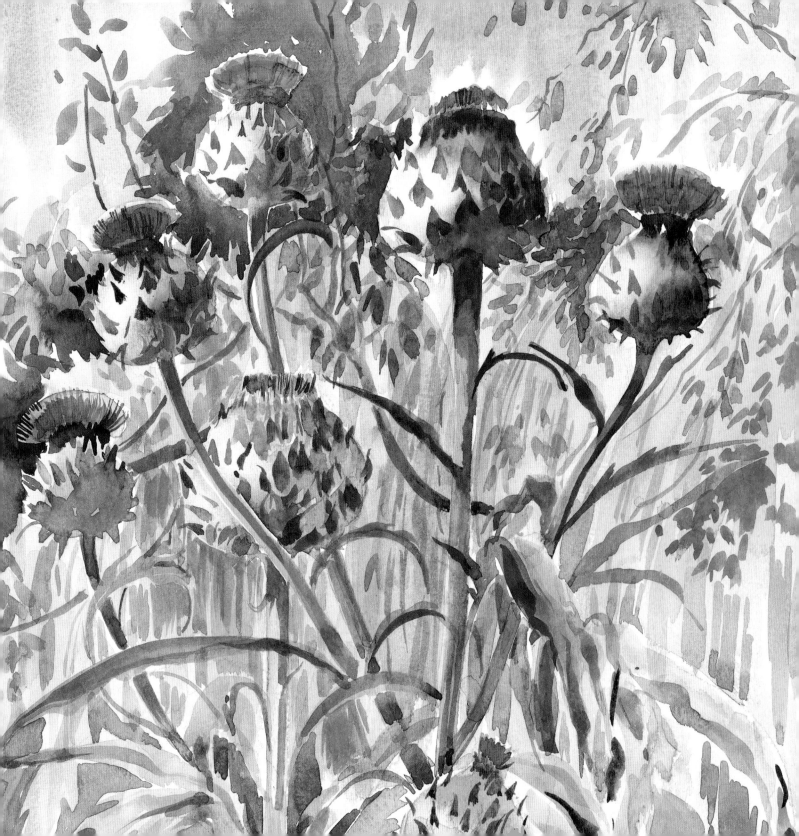

Carnations

Elegant and glamorous, carnations are used as symbols of love and thanks. They come in lovely colours, have a delightful scent (the genus includes cottage pinks and sweet williams) and a distinctive shape; the petals, which may be frilled, are held above blue-green sepals.

permanent rose Winsor violet French ultramarine sap green

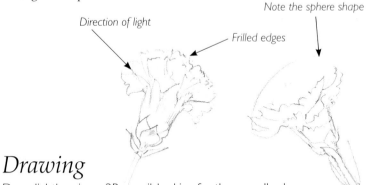

Direction of light

Frilled edges

Note the sphere shape

Drawing

Draw lightly using a 2B pencil, looking for the overall sphere shape and noting the direction of light. Because there are so many small and toothed petals it is difficult to be precise, but be aware of small shadows and darks and lights. The large calyx is important, but the evergreen leaves are fairly insignificant.

Painting a carnation

1 Draw the shape, stem and leaves.

2 Using a No. 12 or No. 8 round brush, wet the carnation shape with clean water and drop in a pale mix of permanent rose to spread and fill the area.

3 When this is nearly dry, blot out some of the paler petal shapes with a folded piece of tissue.

4 Define the other petal shapes with a darker wash of permanent rose.

5 Paint the leaves and stems with a blue-green mix of French ultramarine and sap green, darkening the mix for the shadows.

6 Define the petals further with a mix of Winsor violet and permanent rose, using a No. 4 round brush.

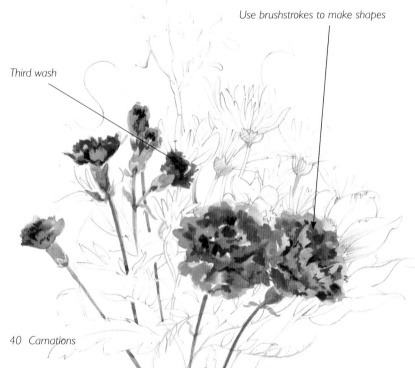

Third wash

Use brushstrokes to make shapes

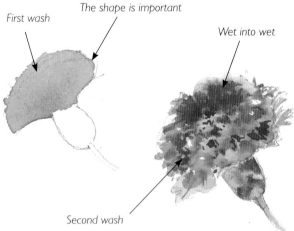

The shape is important

First wash

Wet into wet

Second wash

Keep paint fresh by changing the water frequently

➤ *These carnations were part of a larger bunch of mixed flowers. The long, slender stems of carnations are often best covered by foliage, or they can look isolated and spindly.*

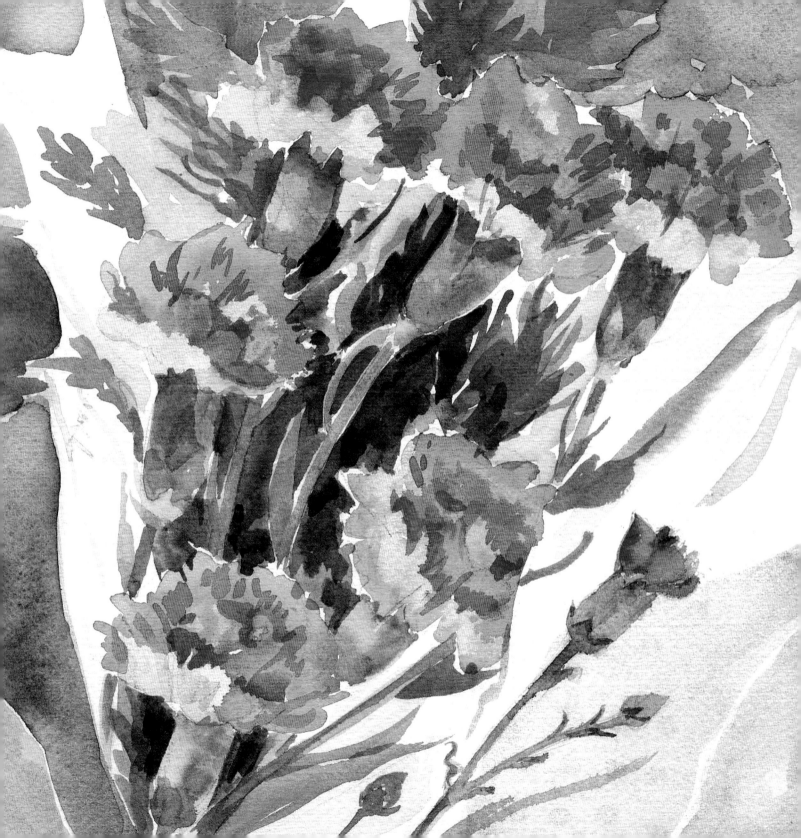

Chinese lanterns

This intriguing plant produces very decorative orange lanterns in the autumn – each attractive, papery lantern is a calyx that carries seeds. Often used as winter decorations, Chinese lanterns can keep their colour right through to the following spring.

Colour palette

cadmium red

cadmium orange

yellow ochre

raw umber

brown madder

Drawing

The lanterns are teardrop-shaped and can be quite large, up to 4cm (1½in). Concentrate on finding the shape, and use the thin ribs to find the form.

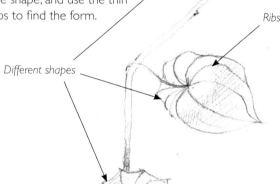

Fine stem

Ribs

Different shapes

Fine stem

➤ *When other flowers are in short supply, Chinese lanterns are useful subjects; you can use all the reds in your palette and even discover new ones! I chose to paint a spray of lanterns against a white wall – the autumn sun made lovely shadows on the wall, and I painted these in a blue-grey.*

Painting a Chinese lantern

Light tone

Darker tone

1 Draw the shape and stem lightly and accurately.

2 Using a No. 8 round brush, paint the lantern with a pale tone of cadmium red or cadmium orange.

3 Note the direction of the light, and paint the dark side of the lantern with a darker mix of red or orange.

4 Paint the ribs with cadmium red, using a No. 4 round brush.

5 Paint the stem next, using yellow ochre and raw umber.

> **Tip:** *You can make an orange by mixing cadmium red with cadmium yellow; use brown madder to make a darker red.*

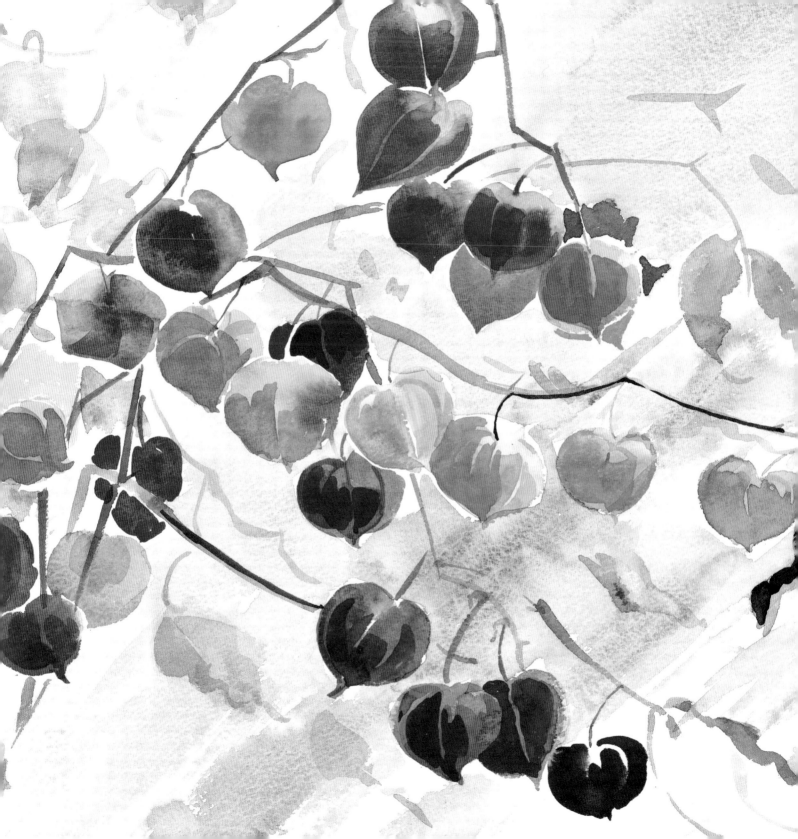

Chrysanthemums

The chrysanthemum is an extraordinarily versatile flower. The variety of flower shapes is amazing – from single, daisy-like blooms to multi-petalled varieties – and there are many colours; some flowers are scented. Chrysanthemums are always available to paint and draw, unlike the majority of flowers, so you can choose them at any time of year.

Colour palette

 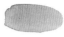

permanent rose magenta sap green

burnt sienna cadmium orange

Note the cluster blooms and different directions of flowers

Shadow side

Free brush shapes

Different ellipses

Soft washes

Dark centre

Overlapping petals

Brush drawing

Drawing

Good observation is essential: look at the basic shape and draw it with a sharp B pencil. Single blooms, which are mostly a shallow bowl or disc shape, are easiest to draw; others, such as pom-pom or ball shapes, are more complicated, and some have very spiky petals. Make sure the stems are placed correctly.

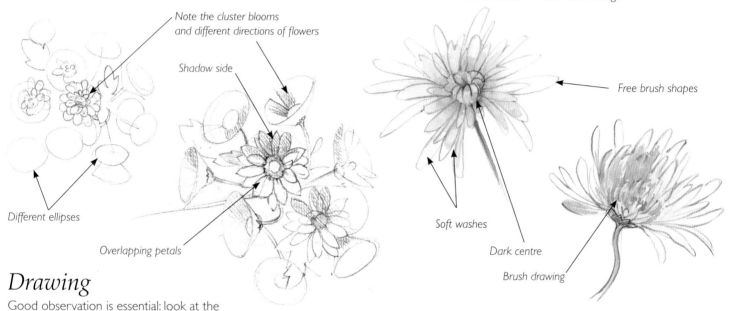

Painting chrysanthemums

1 Draw lightly, then dampen the flower areas with clean water.

2 Using a No. 12 brush, paint the general flower shapes with a very pale wash of permanent rose.

3 While this wash is still wet, drop in the centre using a touch of permanent rose and magenta.

4 If the colour spreads too much, blot it out with a paper tissue to make petal shapes.

5 Using a No. 4 round brush, draw in the petal shapes in a darker pink and indicate the dark petal centres with cadmium orange.

6 Make up a mid-green mix from sap green and burnt sienna, and use this to paint the leaves and stems, with the brush making the shapes.

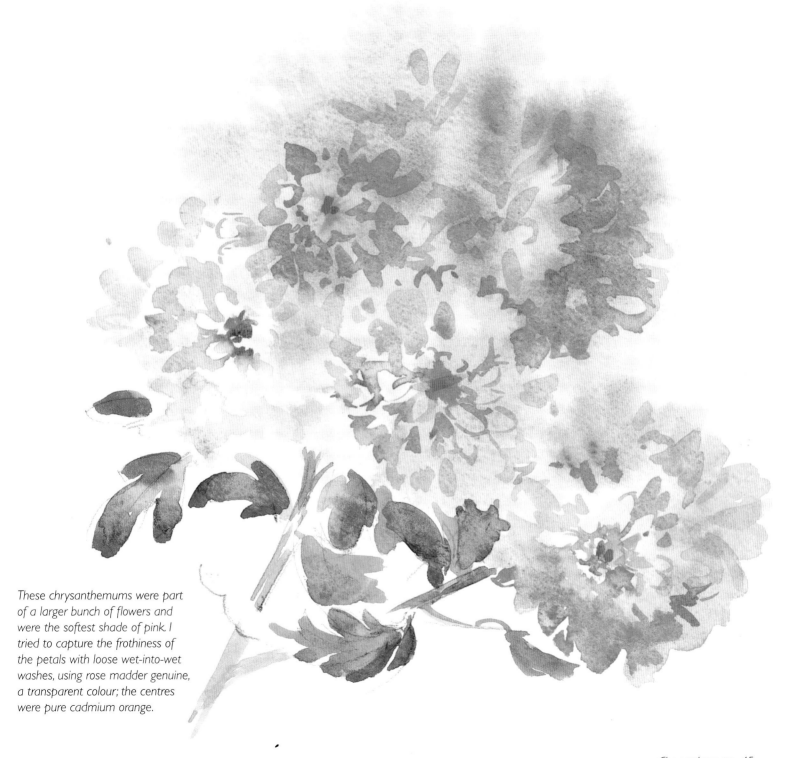

These chrysanthemums were part of a larger bunch of flowers and were the softest shade of pink. I tried to capture the frothiness of the petals with loose wet-into-wet washes, using rose madder genuine, a transparent colour; the centres were pure cadmium orange.

Clivias

Clivias grow well in greenhouses and conservatories, and the striking flowers make a welcome addition in spring. The bright orange-red flowers are like small trumpets on top of a strong stem, and the leaves are strong, strap-like and glossy.

Colour palette

cadmium yellow cadmium red sap green

yellow ochre burnt sienna scarlet lake

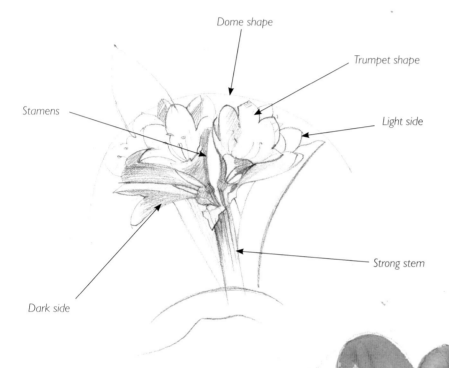

Dome shape

Trumpet shape

Stamens

Light side

Strong stem

Dark side

Painting clivias

1 Draw the shapes carefully.

2 Paint the centre of the flower with a pale wash of cadmium yellow.

3 Follow this with a pale cadmium red, blending in this wash where necessary.

4 Complete the flowers using a darker shade of cadmium red on the shadow side.

5 Paint the stamens and centres using a pale mix of sap green and cadmium yellow.

6 The leaves and stem can be painted using different shades of green, from dark to light, basing the colour on sap green, yellow ochre and burnt sienna.

Drawing

Draw the trumpet shapes with a round dome – there can be as many as ten blooms on one head. The trumpets are attached to a single strong stem; unusually for a trumpet shape, the throat is light in colour.

Working wet into wet

Working wet on dry

Wet base

Tip: You can substitute scarlet lake for cadmium red if you wish; scarlet lake is a transparent colour, whereas cadmium red is opaque.

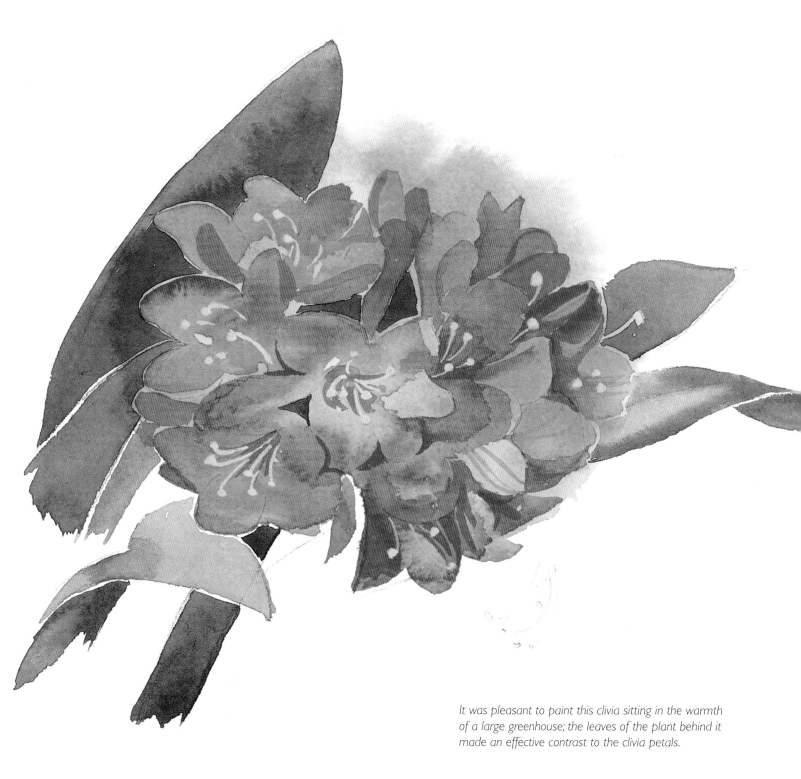

It was pleasant to paint this clivia sitting in the warmth of a large greenhouse; the leaves of the plant behind it made an effective contrast to the clivia petals.

Cyclamens

Cyclamens can be in flower for most of the year and are always delightful. Larger cyclamen in pots can be any shade of pink, red, purple and white, and the smaller, wild varieties are just as entrancing. The heart-shaped leaves are often beautifully patterned.

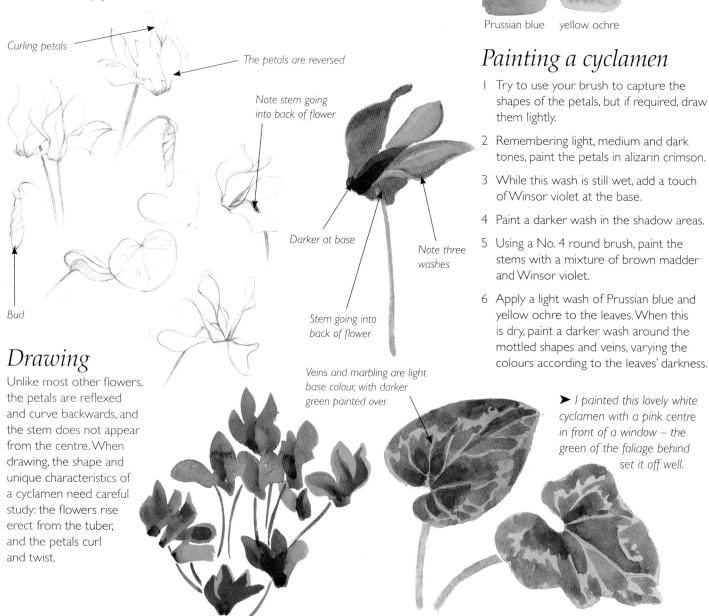

Colour palette

alizarin crimson Winsor violet brown madder

Prussian blue yellow ochre

Curling petals

The petals are reversed

Note stem going into back of flower

Darker at base

Note three washes

Stem going into back of flower

Bud

Painting a cyclamen

1 Try to use your brush to capture the shapes of the petals, but if required, draw them lightly.

2 Remembering light, medium and dark tones, paint the petals in alizarin crimson.

3 While this wash is still wet, add a touch of Winsor violet at the base.

4 Paint a darker wash in the shadow areas.

5 Using a No. 4 round brush, paint the stems with a mixture of brown madder and Winsor violet.

6 Apply a light wash of Prussian blue and yellow ochre to the leaves. When this is dry, paint a darker wash around the mottled shapes and veins, varying the colours according to the leaves' darkness.

Drawing

Unlike most other flowers, the petals are reflexed and curve backwards, and the stem does not appear from the centre. When drawing, the shape and unique characteristics of a cyclamen need careful study: the flowers rise erect from the tuber, and the petals curl and twist.

Veins and marbling are light base colour, with darker green painted over

➤ I painted this lovely white cyclamen with a pink centre in front of a window – the green of the foliage behind set it off well.

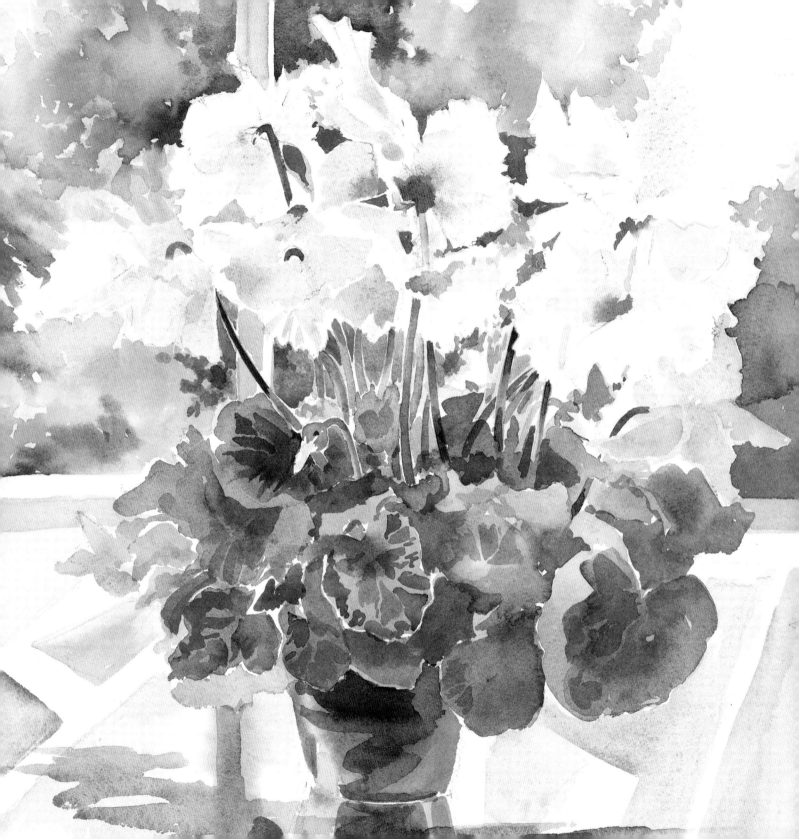

Daffodils

Daffodils are eagerly awaited in spring. We all love to paint them, but it is easy to get into difficulties with the colours and shadows. There are many different yellows, and you should take time to get to know their individual properties: their shades and colours, their transparency or opacity, and their paleness and brightness.

Colour palette

Winsor yellow cadmium yellow permanent rose cobalt blue

French ultramarine sap green yellow ochre

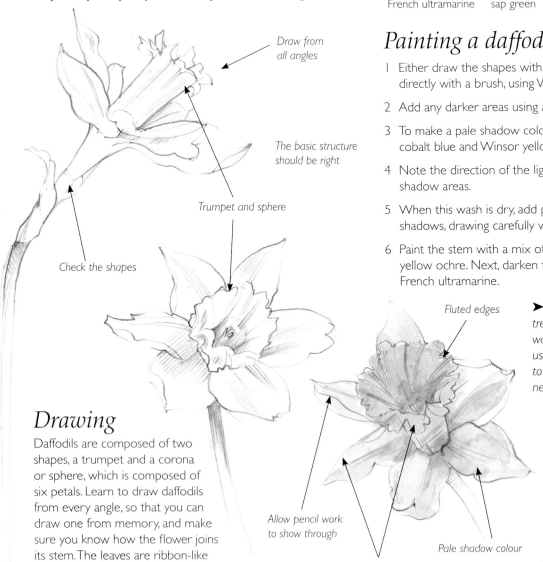

Draw from all angles

The basic structure should be right

Trumpet and sphere

Check the shapes

Fluted edges

Allow pencil work to show through

Pale shadow colour

Two different yellows

Painting a daffodil

1 Either draw the shapes with a pencil or paint them directly with a brush, using Winsor yellow.

2 Add any darker areas using a little cadmium yellow.

3 To make a pale shadow colour, mix permanent rose, cobalt blue and Winsor yellow.

4 Note the direction of the light and paint in the shadow areas.

5 When this wash is dry, add pleats and folds to the shadows, drawing carefully with a B pencil.

6 Paint the stem with a mix of sap green and a little yellow ochre. Next, darken the shadow side with French ultramarine.

➤ *This free and vigorous treatment of a spring bouquet was painted on Rough paper. I used a red watercolour pencil to define the edges of the three nearest flowers.*

Drawing

Daffodils are composed of two shapes, a trumpet and a corona or sphere, which is composed of six petals. Learn to draw daffodils from every angle, so that you can draw one from memory, and make sure you know how the flower joins its stem. The leaves are ribbon-like and twist and turn.

Tip: *It is important to know which yellows are opaque (such as cadmium yellow) and which are transparent (such as aureolin).*

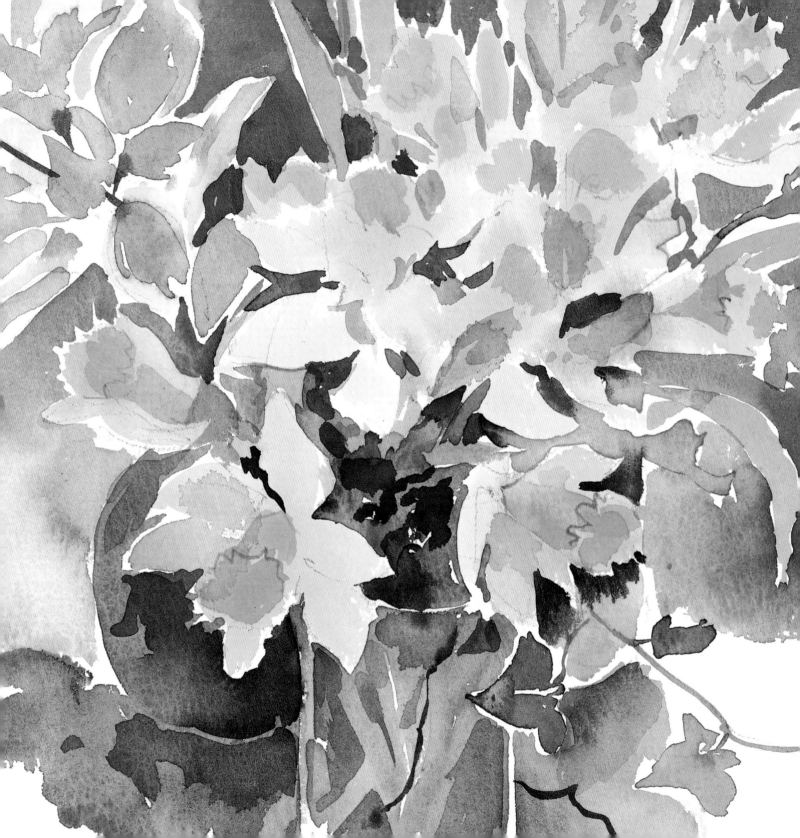

Dahlias

Dahlias are the most sumptuous flowers, extravagant in colour and form and ranging from large and showy to small and precise. Like roses, dahlias are often multi-petalled, and as a result need careful drawing and understanding; make studies first, and note whether the shape is of a pom-pom or more like a ray.

Colour palette

Winsor red · alizarin crimson · brown madder · cadmium yellow

Disc or sphere shape

Central stamens

Pleated and folded petals

Painting a dahlia

1 Draw the petals, noting their shape and size and whether they curve in or out.

2 Start with an overall pale wash of Winsor red.

3 While this is wet, drop in a deeper wash of Winsor red and alizarin crimson.

4 When this is dry, indicate the shadows with an even deeper wash, noting the direction of light.

5 Paint in the centre using cadmium yellow.

6 Use a dark wash of brown madder to paint the sepals and stem.

Drawing

Note the shape and consider your eye level, as the perspective of a sphere can vary considerably. Having drawn the shape, place the petals – these can differ a great deal, as there are about ten flower head forms. Including buds and leaves can help your painting, but the central disc may be obscured by petals.

Single petal

➤ *I painted these dahlias life size indoors against an artificial background. As an artist you have to be particularly observant with these flowers, as they pose a number of questions. Are the petals split? Are they pointed or round? Does the colour change from the inside to the outside?*

Note colour of stem and sepals

Three tones of red

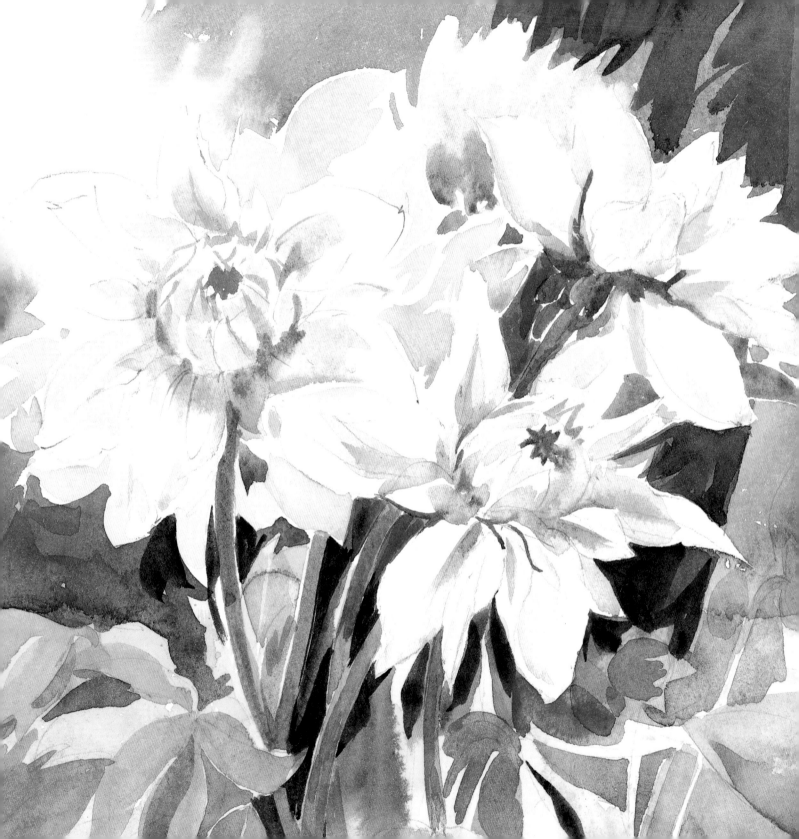

Daisies

Daisy-type flowers always look simple and charming, especially white ones, but you have to be careful with your drawing – make sure you can draw ellipses accurately, and then base your flowers on them. Using the white of the paper for the petals means you have to make decisions early on: are you going to paint around the petals, or will you mask them out?

Colour palette

French ultramarine brown madder yellow ochre

cadmium yellow sap green burnt sienna

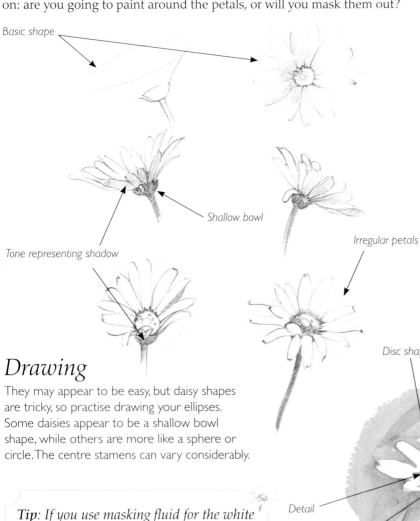

Basic shape

Tone representing shadow

Shallow bowl

Irregular petals

Disc shape Large centre

Detail

Tone

Painting a daisy

1 Draw the shapes.

2 Paint the shadows on the white petals using a grey wash made from French ultramarine and brown madder.

3 Next paint the centres using either yellow ochre or a mix of cadmium yellow and a touch of sap green.

4 Carefully paint around the daisy with a background colour, here a grey-blue mix of ultramarine and brown madder. Make sure you mix enough paint, and use a brush with a point to get between the petals.

5 Paint the stem using a mix of sap green and burnt sienna.

➤ *Putting daisies in a garden setting allows a background to be used. Painting around the flowers can work well, but masking out a mass of small flowers is a valid option. Some artists use gouache successfully, but this must be painted last and on a dark background (see Foxgloves on page 58).*

Drawing

They may appear to be easy, but daisy shapes are tricky, so practise drawing your ellipses. Some daisies appear to be a shallow bowl shape, while others are more like a sphere or circle. The centre stamens can vary considerably.

Tip: *If you use masking fluid for the white petals, coat the brush with washing-up liquid first; the masking fluid will wash out easily when you have finished.*

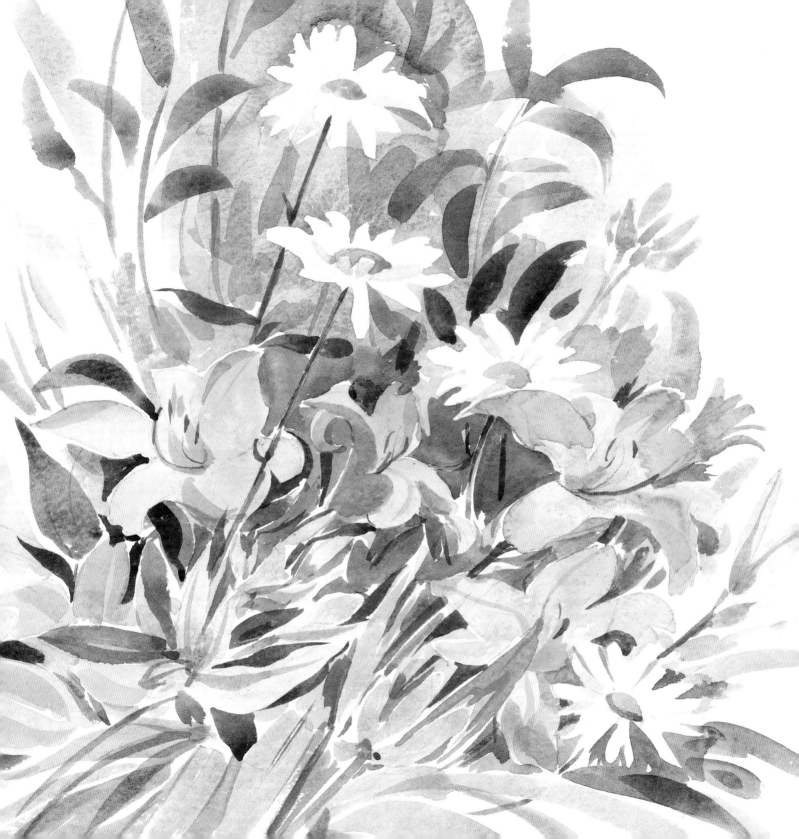

Day lilies

As the name suggests, the flowers of day lilies only last for a day – but a new one will be open in the morning. Day lilies have ruffled, curling petals – double orange, pale orange, red and yellow – and look as good in a painting as they do in a garden; I mostly use them with other plants. Although similar to lilies, day lilies' strap-like leaves and stems come from the base of the plant.

Colour palette

permanent rose cadmium orange olive green

Winsor yellow cobalt blue burnt sienna

Ruffled and veined petals

Stamens

Throat of flower

Light

Stamens

Deeper colour

Ruffled and veined petals

Drawing

The day lily is basically a trumpet shape, but depending on the angle of view, it can look quite different. There appear to be six petals, but three of these are actually sepals. The petals can be ruffled or double.

Painting a day lily

1 Draw or indicate the shape.

2 Using a very pale tint of permanent rose, paint over the flower.

3 Blot off excess paint where the light catches the petals, using a tissue.

4 Paint the centre using cadmium orange and permanent rose, and drop a touch of olive green into the wash.

5 Indicate the shadows with a mix of permanent rose, Winsor yellow and cobalt blue.

6 Paint in any details, such as veins, with darker mixes of the petal colours.

7 Use a mix of olive green and burnt sienna for the leaves.

➤ *Trying to achieve the appearance of flowers growing in a garden can be challenging – distance can be represented, but too many stalks and leaves may need to be structured and balanced.*

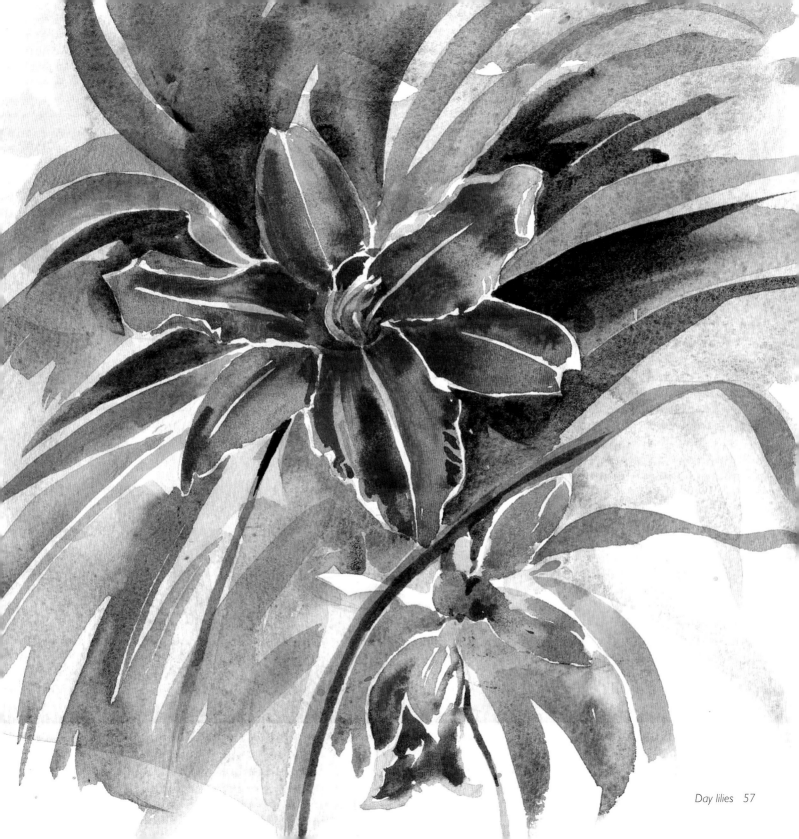

Foxgloves

Tall and stately, foxgloves enrich the garden and can often be found growing wild in the countryside. The flowers can grow on one side of the stem or around the stem; they are tubular and have intriguing spots on the lip. There are buds at the top of the spikes and seed heads at the base.

Colour palette

 alizarin crimson French ultramarine sap green

 burnt sienna Winsor violet

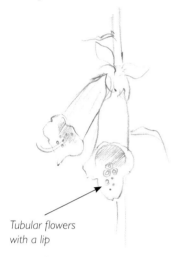

Tubular flowers with a lip

Note how flowers join the stem

Buds open as they get larger

Flowers can grow around stem or just on one side

Drawing

Before you start, look carefully at the structure to understand how foxgloves flower. The flowers are tubular and lipped, and the stem has to be strong to support such a tall plant (up to 2m/6ft). The leaves are mainly at the base, but smaller ones grow up the stem.

Painting a foxglove

1 Does the single foxglove face you or turn away? Be careful to get the drawing right.

2 Mix a purple-red from alizarin crimson and French ultramarine, and paint a pale wash over the flower, leaving small white spaces for the spots.

3 Using a medium wash of the same mix, paint the inside of the tubular shapes to create depth and the turn-back of the petal.

4 Noting the direction of light, use a darker mix for the dark side.

5 Paint the sepals using sap green and burnt sienna.

6 Finish by painting the dark dots using Winsor violet.

Tip: *Gouache, an opaque water-based paint, can be used to highlight or accentuate details in watercolour.*

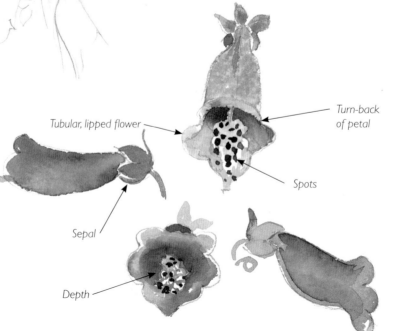

Tubular, lipped flower

Sepal

Depth

Turn-back of petal

Spots

► *This free painting was begun without any preliminary drawing. The dark spaces show up the white flowers, and some detail was added with gouache.*

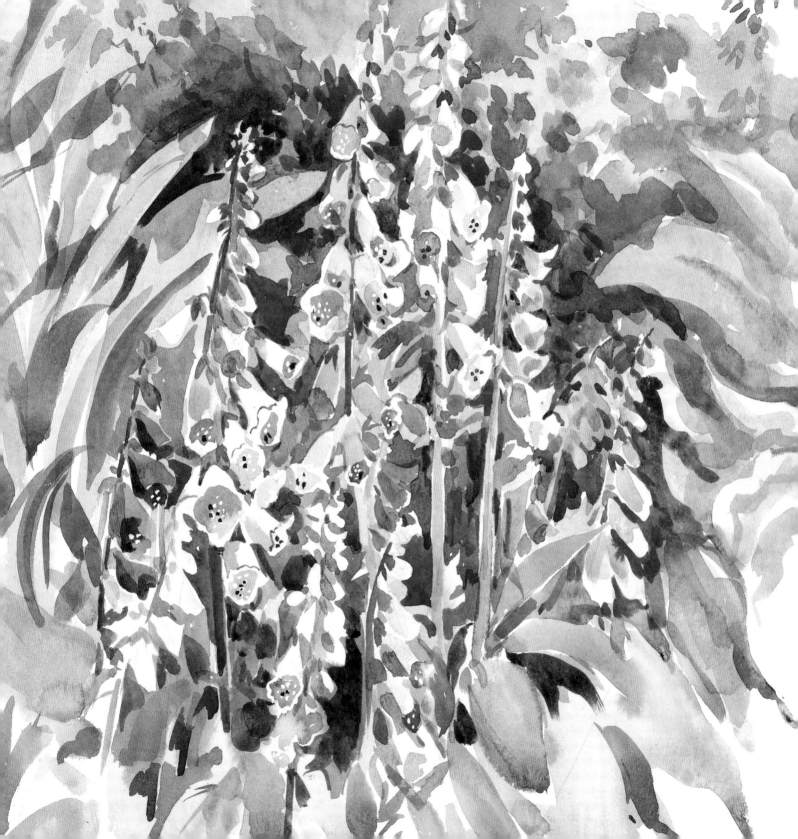

Fuchsias

Also known as Californian fuchsias, these graceful hanging flowers are single or double in reds and purples, and are popular in many gardens. The flowers consist of a tube that opens into sepals and then petals; the stamens are long. There are many varieties of fuchsia, and the plants are easy to grow.

Colour palette

alizarin crimson Winsor yellow sap green burnt sienna

Drawing

Fuchsias usually hang down; observe and draw carefully the three parts – the tube, sepals and petals. The more you observe and draw, the better you will understand the flower and be able to paint it effectively.

Stamens

Outer sepals

Tube

Inner petals

Buds

Painting fuchsias

1 Draw with the brush or, if you don't feel confident enough yet, indicate the positions with a pencil.

2 You may need to stand up to get a good sweep with the brush.

3 Use a mix of alizarin crimson and a touch of Winsor yellow for the petals.

4 Vary the colour of the petals between light, medium and dark.

5 Use a brush with a fine point to paint the stamens.

6 For the stem and leaves, use a mix of sap green and burnt sienna.

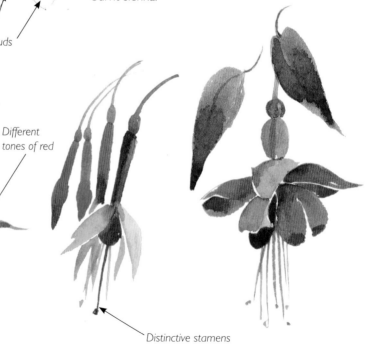

Different tones of red

Fuchsias hang down

Distinctive stamens

Tip: *Why not try painting directly with a brush? Your painting will look fresh and vigorous, and you won't be painting up to edges.*

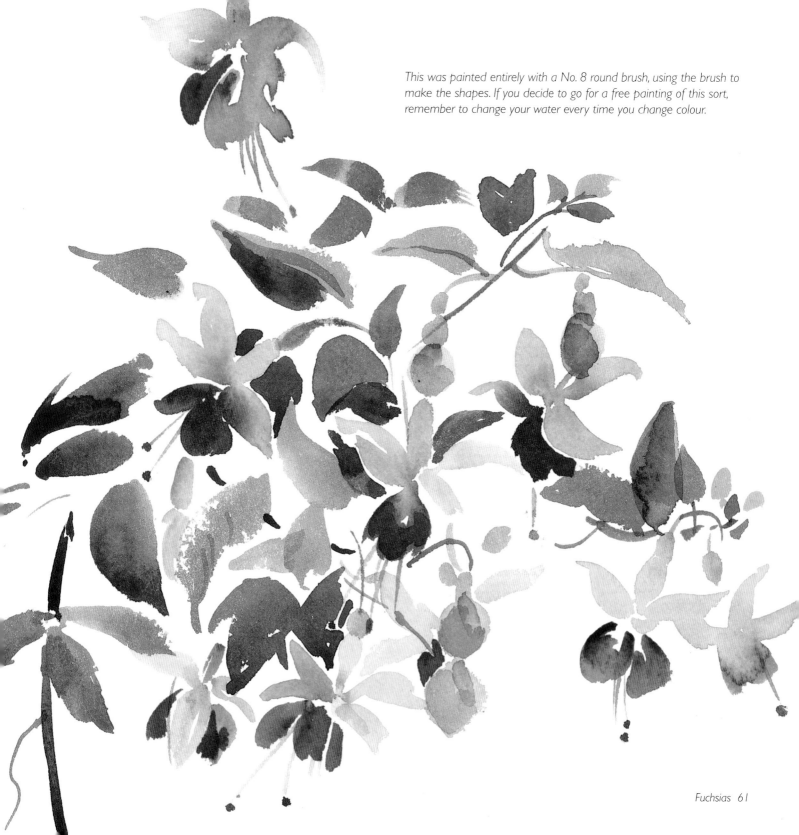

This was painted entirely with a No. 8 round brush, using the brush to make the shapes. If you decide to go for a free painting of this sort, remember to change your water every time you change colour.

Geraniums

Geraniums are equally popular plants in gardens and in pots on windowsills and balconies; their brilliant colours, ranging from white to pink to the deepest red, are very attractive, and sometimes the leaves are scented. The flowers vary in size, and the leaves are either ivy-leaf-shaped or heart-shaped with attractive markings.

Colour palette

permanent rose sap green burnt sienna alizarin crimson

Painting geraniums

1 Draw directly with a brush or, if you don't feel confident enough yet, indicate the positions with a pencil.

2 Paint over the whole flower area with a pale wash of permanent rose.

3 With a medium tone of permanent rose, paint the separate flowers, reserving the light pink of the first wash for the lightest tone.

4 Mix sap green and burnt sienna for the stems and buds.

5 Add details such as the centres of the flowers.

6 For further shadows use alizarin crimson to make a deeper shade of pink.

Drawing

When drawing geraniums, note carefully how the flowers come from a single stem; they often form a dome shape, but not always.

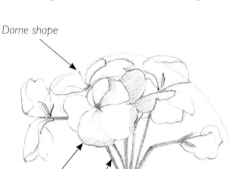

Dome shape

Separate flowers

Separate stems

Buds

Scalloped-edge leaves

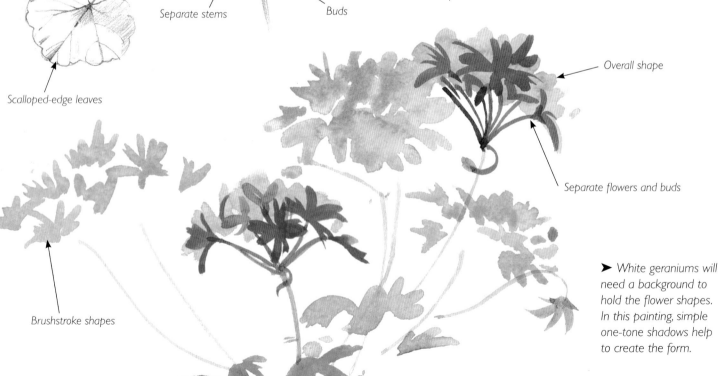

Overall shape

Separate flowers and buds

Brushstroke shapes

► *White geraniums will need a background to hold the flower shapes. In this painting, simple one-tone shadows help to create the form.*

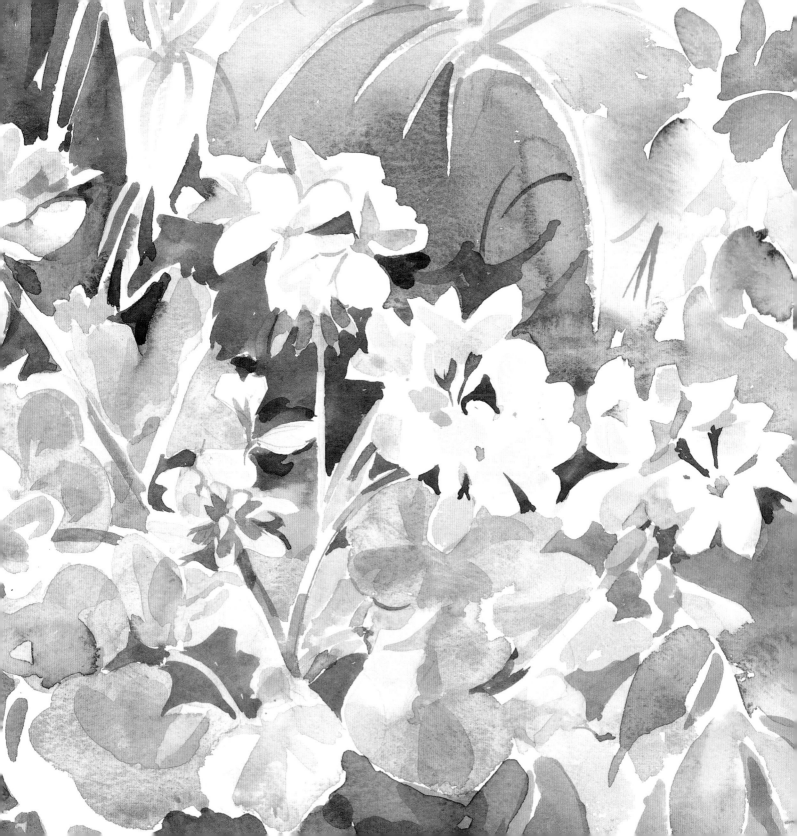

Gladioli

'White' gladioli are not really white, but have subtle tints of the palest greens and pinks. They are an artist's delight, arching and curving in an intriguing way; and because they are tall, large and showy, they can be painted roughly life size, as opposite. Painting very pale and white flowers is all about negative painting – creating the spaces between and around flowers.

Colour palette

French ultramarine

brown madder

permanent rose

sap green

Winsor yellow

yellow ochre

Thick stem

Large bloom

Funnel shape

Frilled edges

Drawing

With a sharp B pencil, draw a funnel shape with the depth facing you. The six petals are often frilled. Use shading to indicate that the stamens come from the base of the funnel.

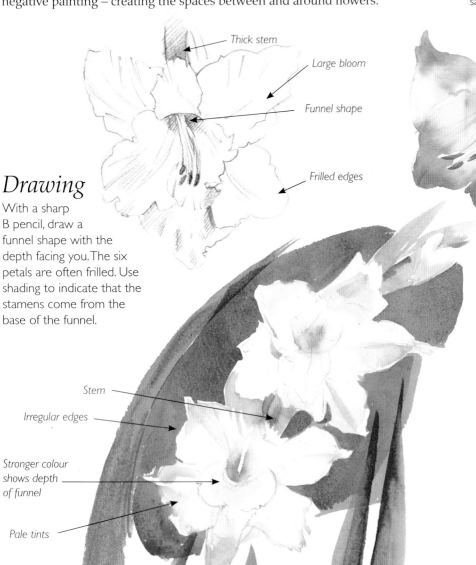

➤ *With a white background, emphasize the subtle colours of the flower; contrast white flowers with a colourful background.*

Stem

Irregular edges

Stronger colour shows depth of funnel

Pale tints

Leaves

Painting gladioli

1　Draw the flowers, including the stems and leaves, using a light pencil line.

2　If the flower is white or pale-coloured, paint around the shape using a suitable background colour; I used varying washes of blue and grey (brown madder and ultramarine), applying them with a No. 12 round brush.

3　Delicately tint the petals with a suggestion of permanent rose, and use a very weak grey wash for the shadows and creases.

4　Darken the centres of the flowers with a pale mix of Winsor yellow and sap green.

5　Paint the stems and leaves with varying mixes and strengths of sap green, Winsor yellow and ultramarine, adding yellow ochre to warm up the colours.

6　Paint the stamens to finish, using diluted blue.

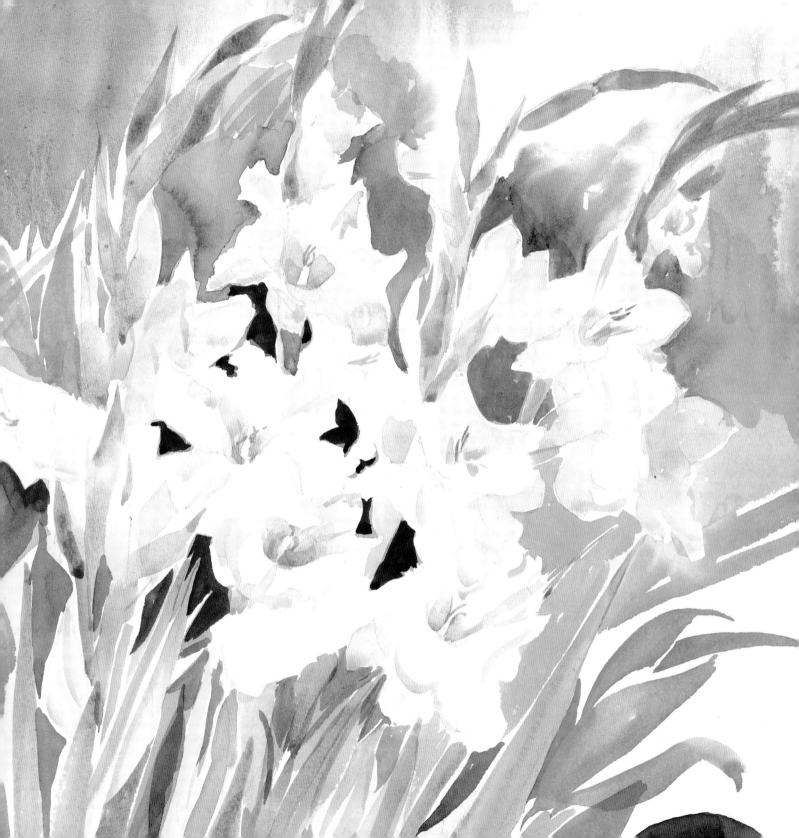

Hellebores

These delicate flowers are a welcome sight in January; they are cup- or saucer-shaped, and vary from the small green flowers of *Hellebore foetidus* to the lovely white, pink and purple flowers of the 'Lenten rose'. The stems are often a reddish green, and the leaves are divided and distinctive.

Colour palette

Naples yellow

permanent rose

Winsor violet

French ultramarine

sap green

Drawing

Draw a hellebore from every angle as the simple-looking shape of the flower can be deceptive. Get the shape right, then put in the centre, leaving the petals and details until last. Note where the light strikes, and remember that shallow cup shapes and saucer shapes can have more depth than appears at first glance.

Flowers mostly hang down, creating shadows underneath

Cup shape

Detail of veins and spots

Painting a hellebore

1 Draw the flower, then use a No. 8 round brush to paint the centre and stamens with Naples yellow.

2 When this is completely dry, mask out the centre and stamens with masking fluid.

3 Wait until the masking fluid is completely dry before painting the petals with a very pale mix of permanent rose and Winsor violet.

4 Make a darker mix of the rose and violet to paint the darker tones on the petals.

5 To capture the form and shape of the petals, paint an even darker mix on the underside.

6 When everything is completely dry, gently rub off the masking fluid, then paint the details around the stamens with a mid-green wash mix of sap green and French ultramarine.

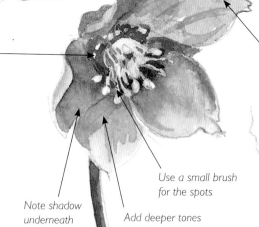

Masking fluid

Light hitting top of flower

Note shadow underneath

Add deeper tones

Use a small brush for the spots

Tip: *Don't leave masking fluid on paper for too long or it will disturb the surface; if possible, rub it off the same day you apply it.*

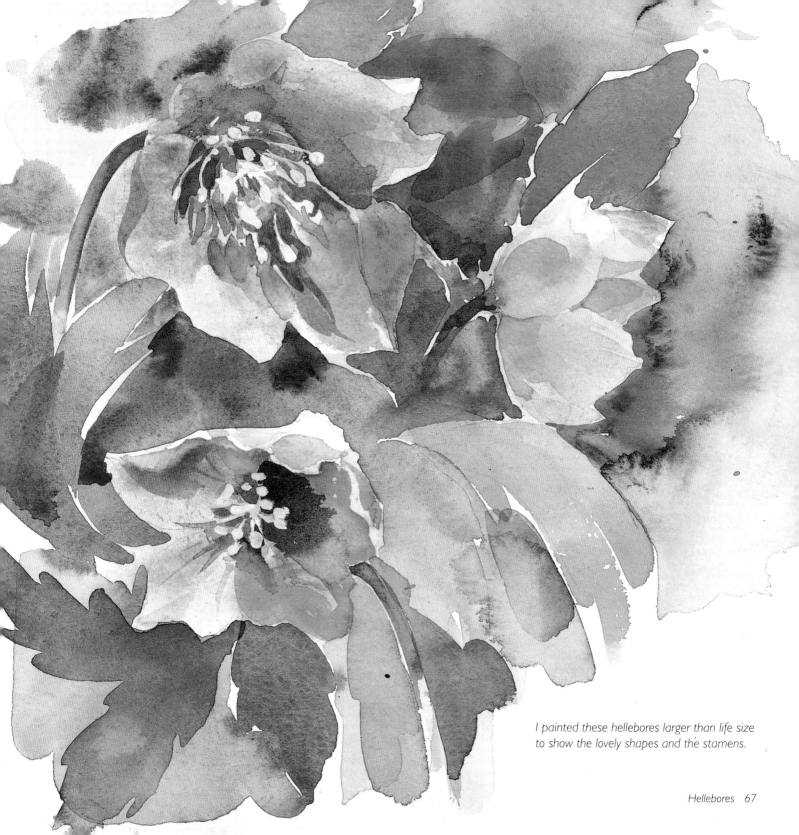

*I painted these hellebores larger than life size
to show the lovely shapes and the stamens.*

Hibiscuses

The hibiscus is an exotic flower found all over the world and is lovely to paint. The large flower, which may only last for a day, comes in a variety of colours, red, white, pink, purple and even yellow, and the trumpet-shaped flower has striking stamens on a central column. Some hibiscuses are hardy shrubs, but many are grown as pot plants in conservatories and greenhouses.

Colour palette

Winsor yellow cadmium red alizarin crimson

sap green burnt sienna yellow ochre

Drawing

The hibiscus is basically a trumpet shape; the five petals can have frilled edges, but the most striking part of the flower is the column from which the stamens and pistil spring. There are veins and pleats, and some flowers can feature stripes on the petals.

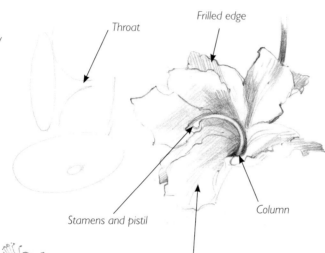

Throat

Frilled edge

Stamens and pistil

Veins and pleats

Column

Painting a hibiscus

1 Draw the shape, including some buds, leaves and stems.

2 Paint the whole flower with a light wash of Winsor yellow.

3 While this is wet, drop in a darker mix of Winsor yellow and cadmium red to make soft shadows.

4 When this is dry, use the same wash to paint the pleats and folds wet on dry.

5 Use alizarin crimson to softly indicate the dark centre of the flower.

6 Paint the leaf and stem using a mix of sap green, burnt sienna and yellow ochre.

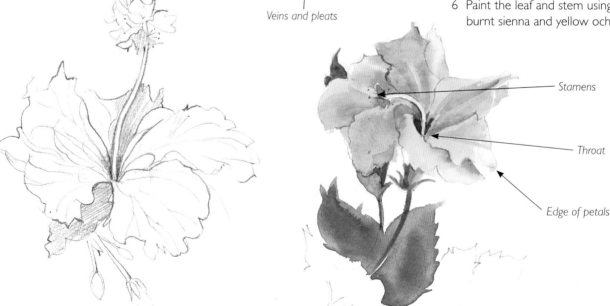

Stamens

Throat

Edge of petals

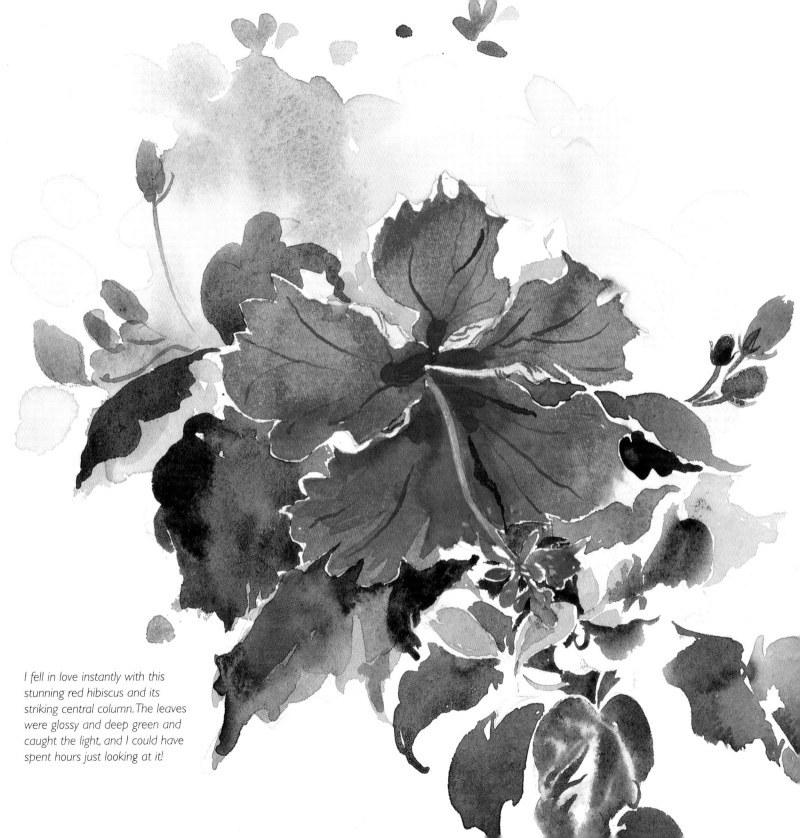

I fell in love instantly with this stunning red hibiscus and its striking central column. The leaves were glossy and deep green and caught the light, and I could have spent hours just looking at it!

Honeysuckles

The sweetly scented honeysuckle has delicate, tubular flowers that bloom over a long period. The stamens are often very noticeable and add to the charm of the plant. The flowers are attractive to bees and moths, and can be white, cream, yellow or tinged with red.

Colour palette

Naples yellow alizarin crimson oxide of chromium

Drawing

This honeysuckle (*Lonicera fragrantissima*) blooms in winter and is, as its name suggests, highly scented. The flowers are small and tubular, and flare out; study it carefully and use a sharp pencil when drawing it.

Delicate flowers

Leaves hardly emerging

Stamens

Two tones on flowers

Tip: When painting small flowers such as this, contrast is all-important: you need to think about light flowers on dark, and dark flowers on light.

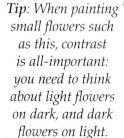

Stamens drawn with pencil

Flowers have five lobes

Painting a honeysuckle

1 Draw the shape.

2 Using Naples yellow, paint the petals, blending in a little alizarin crimson towards the throat of each flower.

3 Draw in the stamens with a sharp pencil.

4 Paint the leaves using a light and a medium tone of oxide of chromium.

5 Use oxide of chromium to paint the stem.

6 Add a shadow side to the stem using a touch of alizarin crimson.

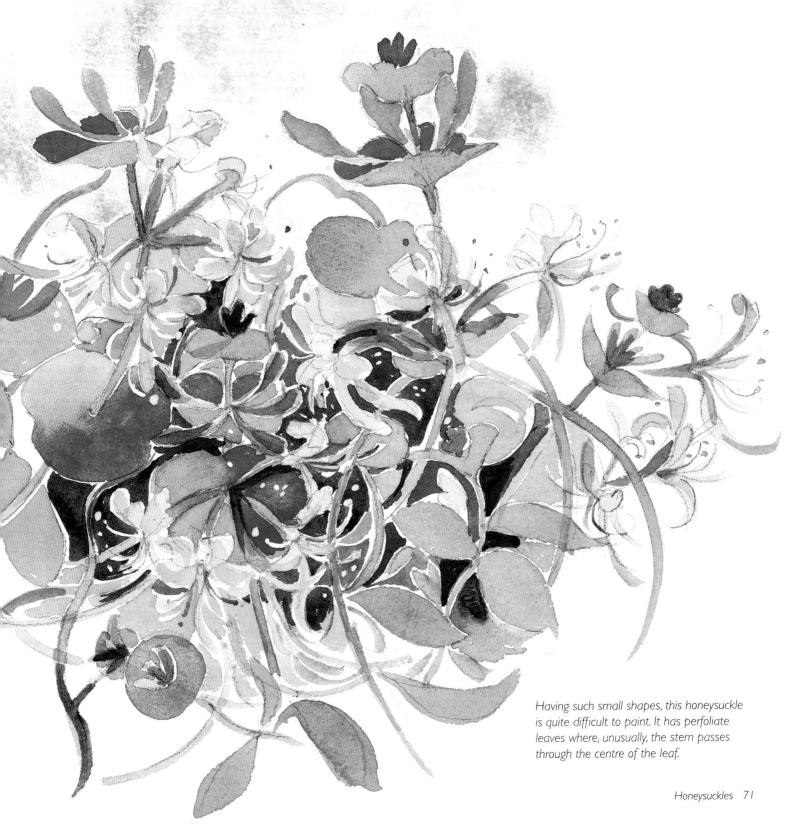

Having such small shapes, this honeysuckle is quite difficult to paint. It has perfoliate leaves where, unusually, the stem passes through the centre of the leaf.

Hyacinths

The scent of hyacinths can fill a room in winter, and the beautiful bell-shaped flowers around a single stem can be found in many colours. Hyacinths really need to be treated as a mass, that is as an overall shape, paying attention to the contours while adding a few individual flowers.

Colour palette

 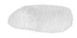

French ultramarine Winsor violet cadmium yellow burnt sienna

Bell-shaped flowers

Buds

Three tones of blue/violet: light, medium and dark

Drawing

Draw with a B or 2B pencil, noting carefully the way the flowers grow around the strong, thick stem. The flowers are bell-shaped and the leaves are sturdy; include the bulb.

Enclosing leaves

Stem

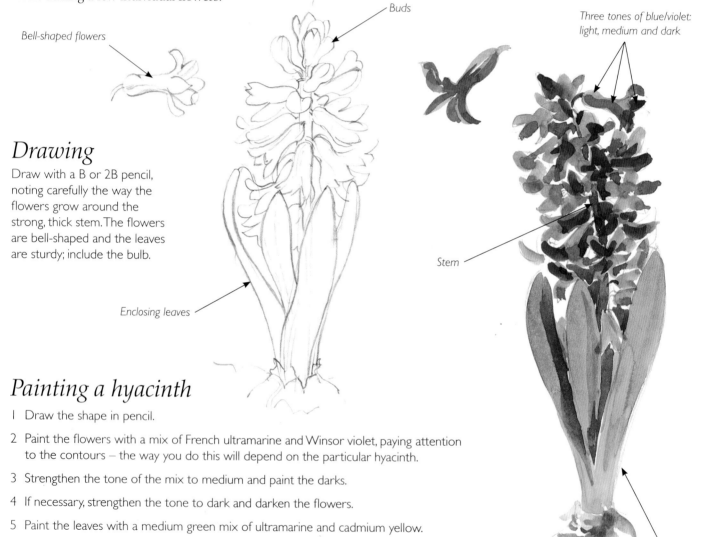

Painting a hyacinth

1 Draw the shape in pencil.

2 Paint the flowers with a mix of French ultramarine and Winsor violet, paying attention to the contours – the way you do this will depend on the particular hyacinth.

3 Strengthen the tone of the mix to medium and paint the darks.

4 If necessary, strengthen the tone to dark and darken the flowers.

5 Paint the leaves with a medium green mix of ultramarine and cadmium yellow.

6 Add a shadow side to the leaves with a darker green mix, and also use this for the stem.

7 The bulb can be a mix of burnt sienna and ultramarine.

Contour

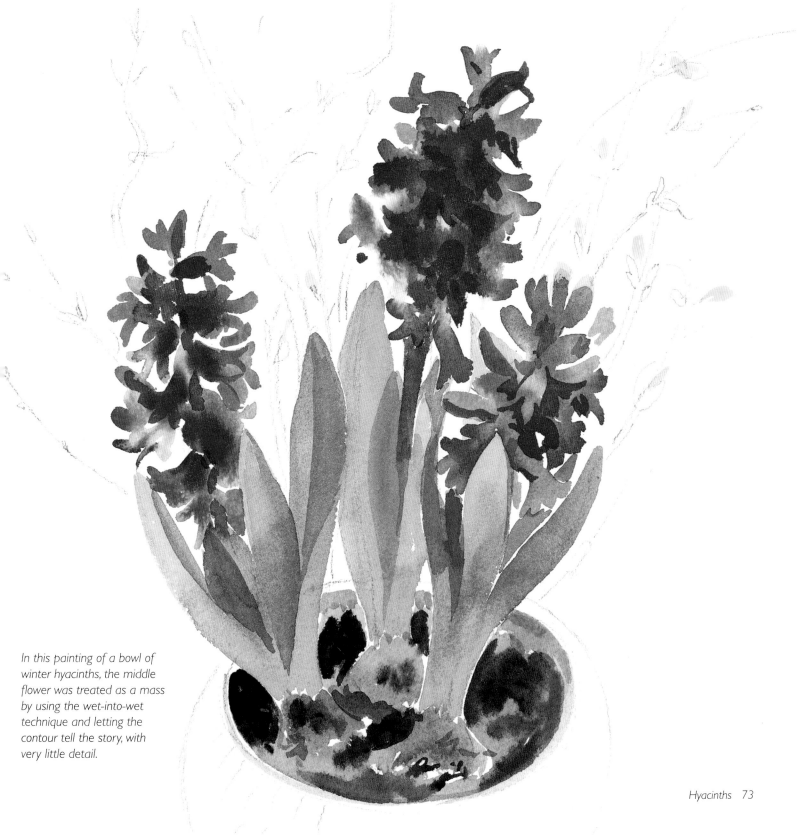

In this painting of a bowl of winter hyacinths, the middle flower was treated as a mass by using the wet-into-wet technique and letting the contour tell the story, with very little detail.

Hydrangeas

Hydrangeas are often in bloom when other flowers aren't; they make useful additions to arrangements, with subtle tints and colours. Some people seem to find painting them a problem, but they aren't really difficult: use the same approach as for other multi-flowered plants – shape first, detail later – and what a wonderful subject to practise your wet-into-wet skills on!

Colour palette

permanent rose cobalt blue Winsor yellow

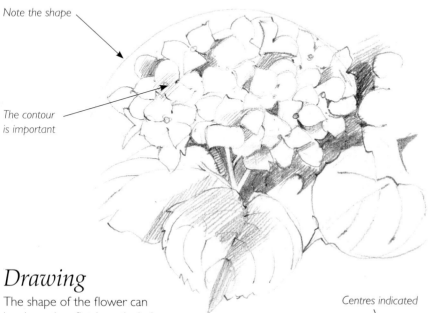

Note the shape

The contour is important

Drawing

The shape of the flower can be domed or flat. I particularly like the look of this flower from the back, where you can see the decorative small branches and stem. The leaves are large and serrated, with interesting veins, and provide a foil to the flower.

Tip: *Tear or cut petal shapes from blotting paper or thick tissue, and use these to lift off wet paint to make pale petals; tidy up the shape afterwards.*

Painting a hydrangea

1 Draw the shape in pencil if necessary; otherwise, dampen the paper with clean water.

2 Drop in a pale pink wash of permanent rose – don't worry if this spreads.

3 While this first wash is wet, mix a grey from permanent rose, cobalt blue and Winsor yellow, and use this on the dark side of the flower.

4 While everything is damp, blot out the shapes of some of the very palest petals using a tissue or blotting paper cut to shape.

5 Use a darker mix of permanent rose to define some petals and add detail as you go; strengthen the colour if necessary.

6 Add some centres with variations on the grey mix.

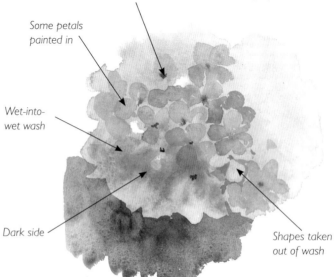

Centres indicated

Some petals painted in

Wet-into-wet wash

Dark side

Shapes taken out of wash

➤ *If you rely on the background to give shape to a flower such as a hydrangea, you must be careful with the silhouette – sometimes a soft edge that contrasts with a hard one can be descriptive, and leaves can often help, providing a dark shape against the light flower.*

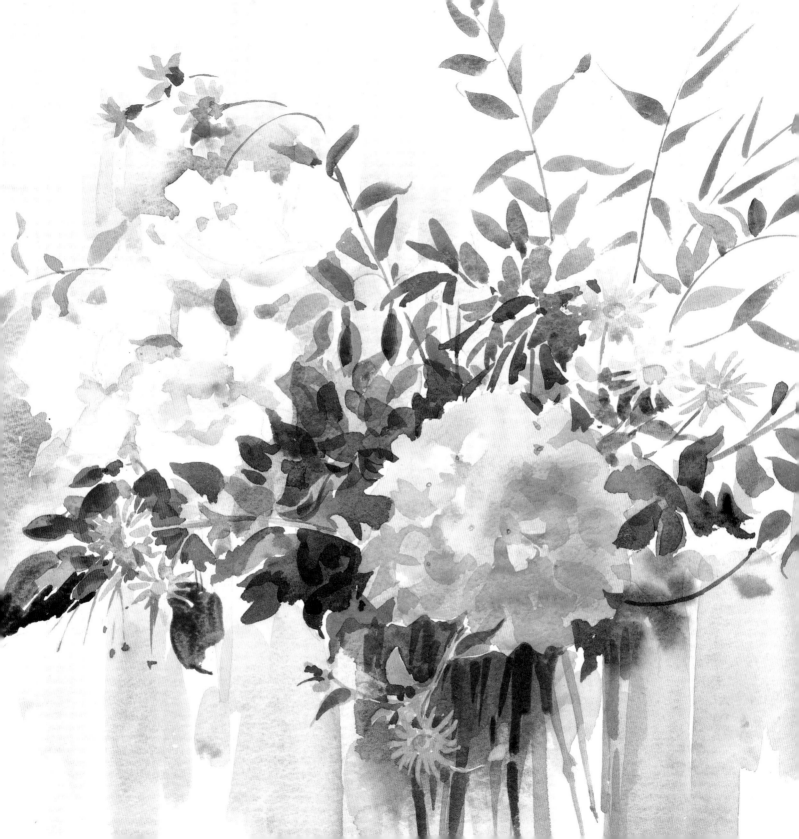

Irises

There are many different types of iris, all of which are delightful to draw and paint. A particular favourite is the bearded iris, which comes in a variety of beautiful colours, including mid-blue, purple, white and yellow, and has large flowers and lovely buds. The flowers are intriguing and need to be studied closely: they have three inner petals and three outer petals that hang down.

Colour palette

Winsor violet gamboge sap green burnt sienna

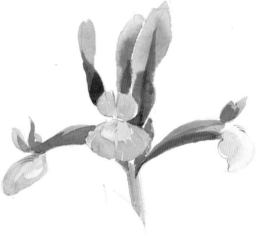

Drawing

Study the shapes and draw them life size. Use the leaves as a foil to the flowers: the leaves are stiff and sword-shaped, while the petals can be irregular and be blown by wind, making them hard to draw.

Varied line

Inner petals

Veining

Note different arrangement of petals

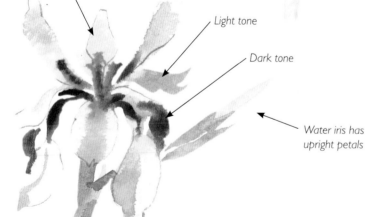

Light tone

Dark tone

Water iris has upright petals

***Tip:** Make a viewfinder by cutting a square out of a sheet of card and choose your composition.*

Painting an iris

1 Draw the shape in pencil, noting the arrangement of petals.

2 Paint the petals with a pale wash of Winsor violet.

3 While this first wash is drying, paint the yellow parts of the petals with gamboge.

4 Mix a darker shade of violet and use this to show the shaded parts and bring out the form of the petals.

5 Paint the stem and leaf with a mix of sap green and burnt sienna.

6 Add a little burnt sienna to gamboge for the darker parts of the yellow petals.

➤ *This bearded iris has the most beautiful petals, which wave about in the wind. The background in this painting uses pale washes of the same colours as the iris petals.*

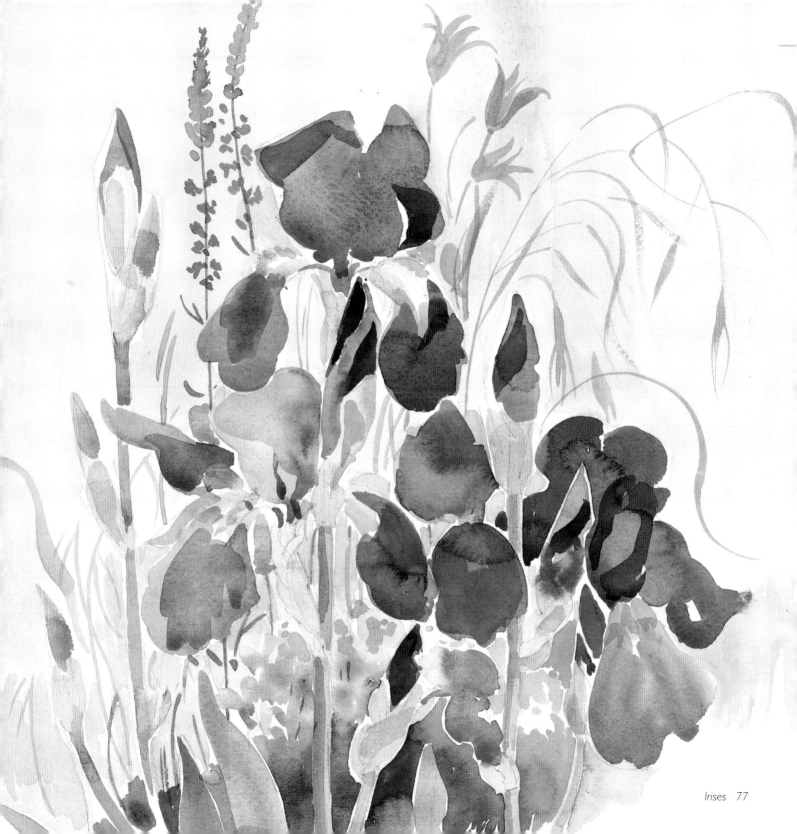

Lilacs

Lilac (*Syringa vulgaris*) appears in late spring and has a lovely scent. The flowers, which are small and can be either single or double, grow in clusters around central stems – when painting them, you have to treat them as a mass. The tubular flowers can be white, purple, lilac or dark red.

Drawing

Start by drawing a general shape, a dome or plume, and then fit the flowers, buds and tiny stems into this shape; the small, tubular flowers grow around the stems, and you don't have to draw all of them to give a convincing impression.

Colour palette

ultramarine violet alizarin crimson olive green

sap green raw umber burnt umber

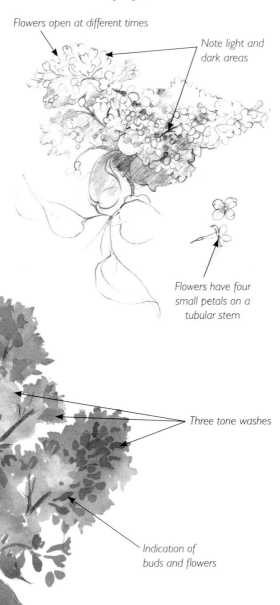

Flowers open at different times

Note light and dark areas

Flowers have four small petals on a tubular stem

Light and dark areas

Three tone washes

Indication of buds and flowers

Painting a lilac

1 Draw the shape in pencil, or paint straight away using a light wash of ultramarine violet.

2 Note the light areas and either darken the adjacent parts with the violet or alizarin crimson, or blot out some colour from the wet wash with a tissue.

3 Indicate the individual flower buds by using a darker wash.

4 To give structure to the flower heads, paint small and large stems with a mix of olive green and sap green.

5 Paint the leaves with a medium wash of the two green colours.

6 Mix raw umber and burnt umber to paint the other stems.

Tip: When painting a lot of small florets as in this lilac, don't attempt each flower, but paint the whole shape and indicate several flowers.

➤ *These purple and white lilacs were growing side by side on top of a tall bush; their heady fragrance was quite overwhelming.*

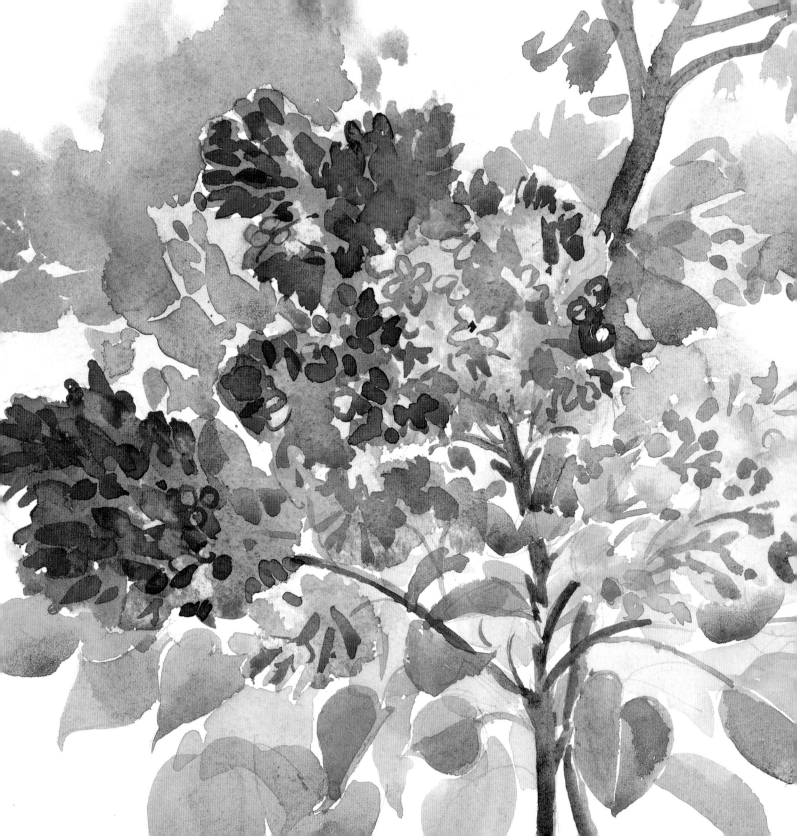

Lilies

Whether fragrant or unscented, lilies are beautiful. The flowers are mainly trumpet-shaped and the buds are often decorative, and lilies are reasonably simple to draw. Try painting the lovely shapes any way you can; in a landscape or in pots on a patio, for example.

Colour palette

permanent rose

cobalt blue

Winsor yellow

sap green

burnt sienna

cadmium orange

➤ *When regale lilies flower I am overwhelmed by the scent and the pure shapes – no wonder lilies are popular as symbols of purity and grace. The petals can curve in different ways, with the flowers pointing up or down.*

Drawing

Lilies are trumpet-shaped when seen in profile, but from the front they are more difficult to draw; try to achieve the depth of the trumpet using shading. It's easier to draw life size, drawing a box shape and then defining the petals.

Six petals

Draw a box shape with petals radiating from the centre

Stamens

Turned-over petals

Tones

Curly petals

Detail in centre

Tip: *When painting white flowers, you can define the edges with a pencil line.*

Painting lilies

1 Indicate the shapes with fine pencil lines.

2 Mix a shadow colour from permanent rose, cobalt blue and Winsor yellow, and paint this, keeping to a single tone.

3 Add details: paint the stamens using cadmium orange, and the stalks are a pale green made up of sap green and Winsor yellow.

4 For the pinky-mauve petals, use a light wash of permanent rose and cobalt blue.

5 Paint the stem and leaves using a mix of sap green and burnt sienna.

6 Add more tone to the existing shadows with a darker version of the shadow mix.

7 Dampen the background area to make the washes run more easily, and then drop in darkish shadow mixes, working quickly so the washes blend.

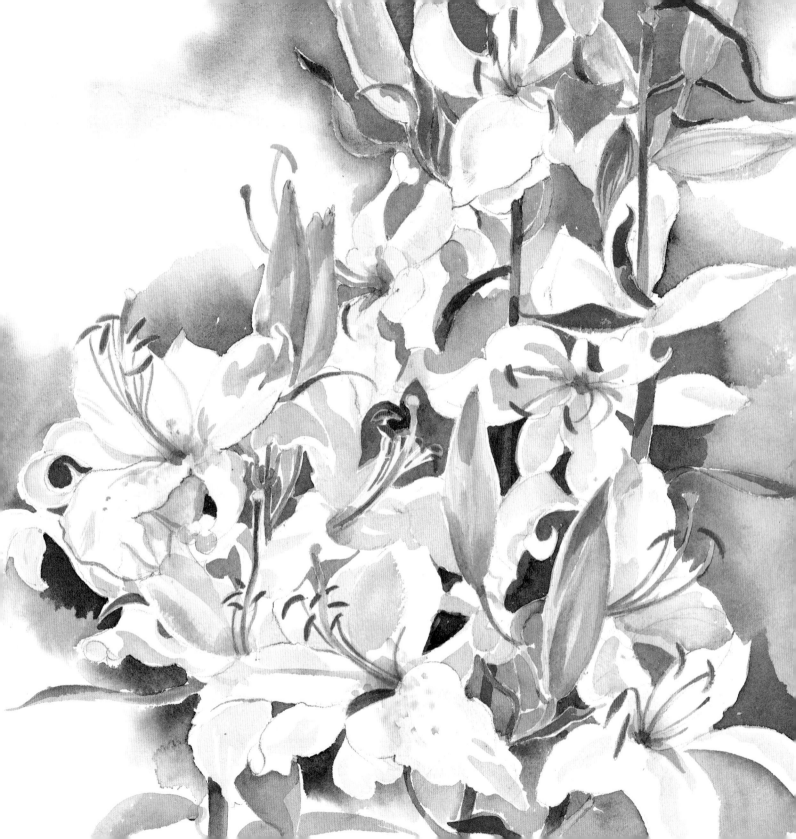

Lupins

Lupins are impressive, imposing flowers that can grow as tall as 1m (3ft); the garden varieties have a stunning array of colours – some are bi-coloured – and make a vivid display. The many individual flowers, which are often scented and which grow around a central stem, are sweet-pea-shaped, and are best painted as a mass.

Colour palette

Winsor yellow cadmium red French ultramarine sap green

Sweet-pea shape

Buds at the top

Flowers arranged in tiers around stem

Drawing

You can draw a lupin as a botanical specimen or treat it quite loosely – whichever method you choose, capturing the character of the flower is important. The top of the spike is tightly packed, and the pea-like flowers open as they go down the stem. The leaves are distinctive and decorative.

Painting lupins

1 Draw the shapes loosely in pencil.

2 Paint the flowers as a mass with a pale wash of Winsor yellow and cadmium red.

3 When this wash is dry, paint in some individual flowers with a deeper wash.

4 Add a little French ultramarine to the wash for the shadows.

5 Paint the stems and leaves using a mix of sap green and ultramarine.

6 To show the contours of the lupins, paint in a background wash of ultramarine and drop a little sap green into it here and there.

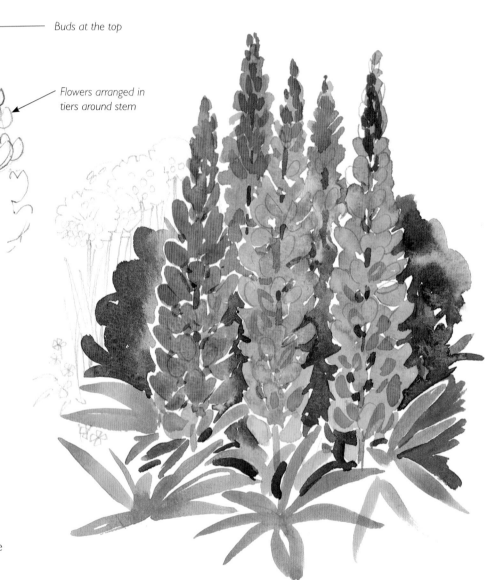

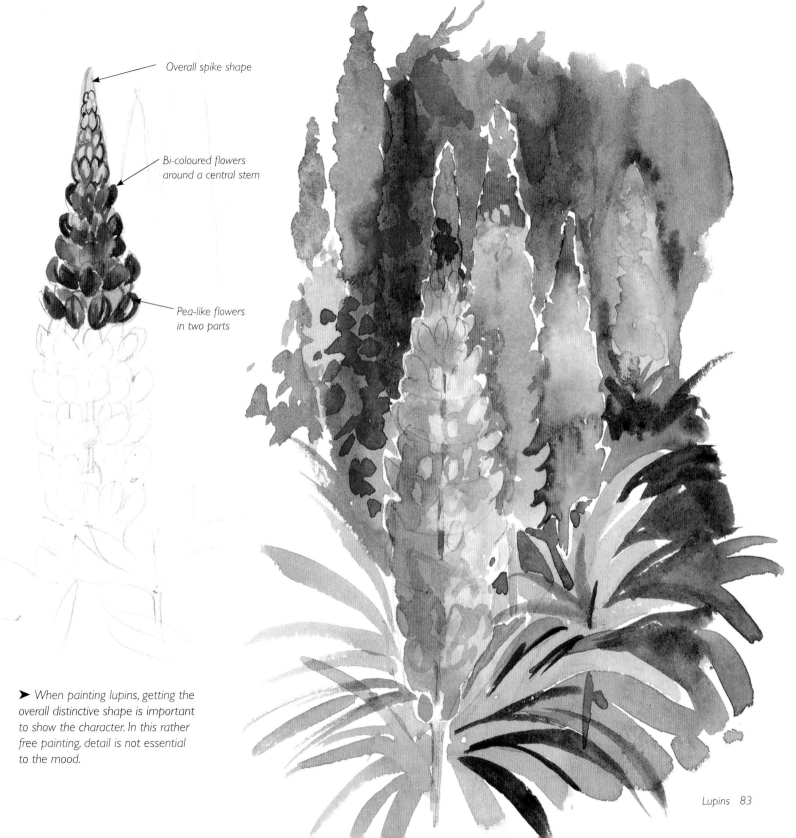

Overall spike shape

Bi-coloured flowers
around a central stem

Pea-like flowers
in two parts

➤ When painting lupins, getting the
overall distinctive shape is important
to show the character. In this rather
free painting, detail is not essential
to the mood.

Magnolias

Around Easter, magnolia flowers appear, shaped like small wine glasses in white, pink and purple, and lasting a long time before they fade; if attacked by frost, the waxy petals turn brown. The buds have lovely shapes, and sometimes you can see full-blown flowers, half-open ones and buds in varying stages on the same branch. When painting magnolias against a spring sky, the question is whether to paint the background before or after the flowers: try it both ways.

Colour palette

permanent rose French ultramarine cobalt blue raw umber

sap green magenta raw sienna

Drawing

Magnolias start as a goblet shape and open right out in the sun, so try to draw them at all stages of this process if possible. Note particularly the stamens and small leaves.

Goblet shape

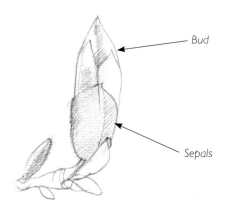

Bud

Sepals

Light

Tone and shadow

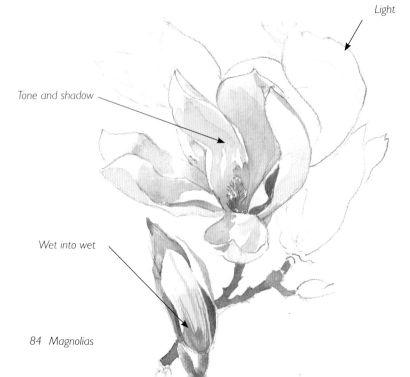

Wet into wet

Painting magnolias

1 Draw or indicate the shapes loosely in pencil.

2 The flower is basically white; paint on pale pink or purple washes using permanent rose or magenta.

3 Deepen the colours towards the centre, possibly adding a little French ultramarine to the wash.

4 Tones and shadows indicate the form, but the background makes the shape. Working wet on dry, mix up a large cobalt blue wash and speedily paint around the flowers.

5 To work wet into wet, dampen the paper around the flowers with clean water, then drop the paint onto the wet areas.

6 Paint the stems and sepals using sap green and raw umber, and use raw sienna for the stamens.

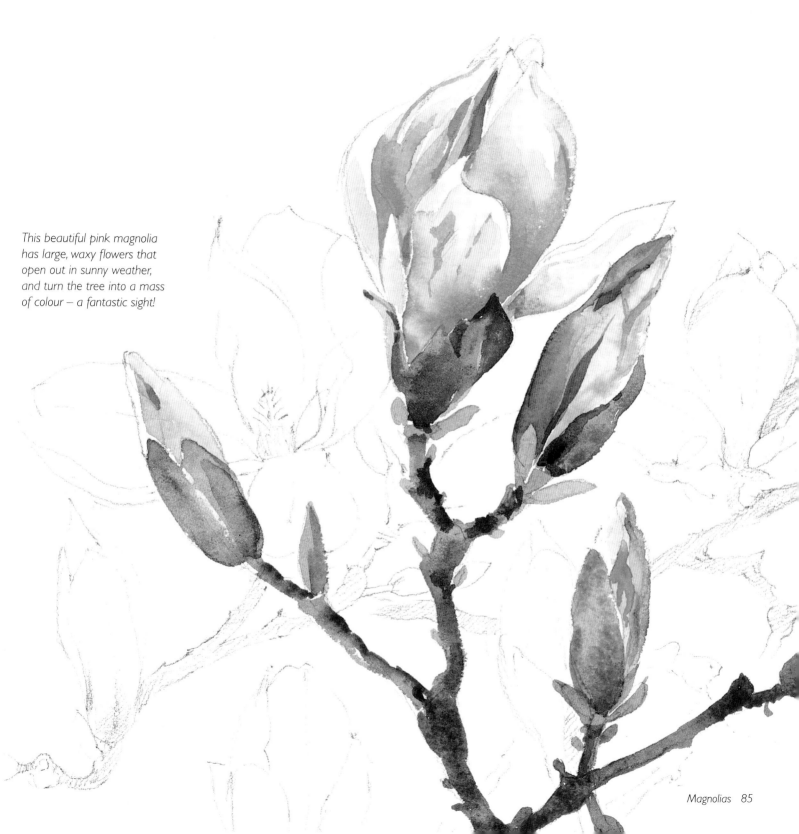

This beautiful pink magnolia has large, waxy flowers that open out in sunny weather, and turn the tree into a mass of colour – a fantastic sight!

Nasturtiums

Nasturtiums are easy to grow, and their bright colours – yellow, orange and red, and often a mixture – and rounded leaves make them a favourite in any garden. The flowers have appealing and distinctive spurs at the base that give them the appearance of monks' hoods.

Drawing

The flower is basically trumpet-shaped and has five petals. Note the spur at the base and the fact that the petals have cut-out bases where they go into the sepal. In comparison, the leaves are flat and circular and are thus easier to draw, but look carefully at the quite intricate veining.

Spur at base

Shape based on trumpet

Circular leaf

Veining and cut-outs

Sepals

Colour palette

cadmium red cadmium yellow sap green alizarin crimson

Painting nasturtiums

1 Draw or indicate the shapes loosely in pencil if you like; otherwise, go straight in with a brush.

2 Cadmium red and cadmium yellow are strong, opaque colours, so use them boldly as you paint the petals; alizarin crimson is less opaque, but you can use it in the same way.

3 Use a No. 4 round brush to paint the stems in a pale sap green.

4 Mix up a clear, bright green from sap green and cadmium yellow, and paint over the leaves.

5 When the leaf is dry, mix a darker green and go over the leaves again, this time leaving the veins as the pale first wash.

6 Finish by adding any details and shadow areas, using darker versions of the mixes.

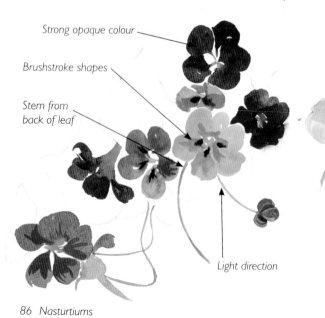

Strong opaque colour

Brushstroke shapes

Stem from back of leaf

Light direction

➤ Nasturtiums always seem to grow in a tangle of stems, leaves and flowers. In this painting I included buds, seed pods and the spurs at the base of the flowers.

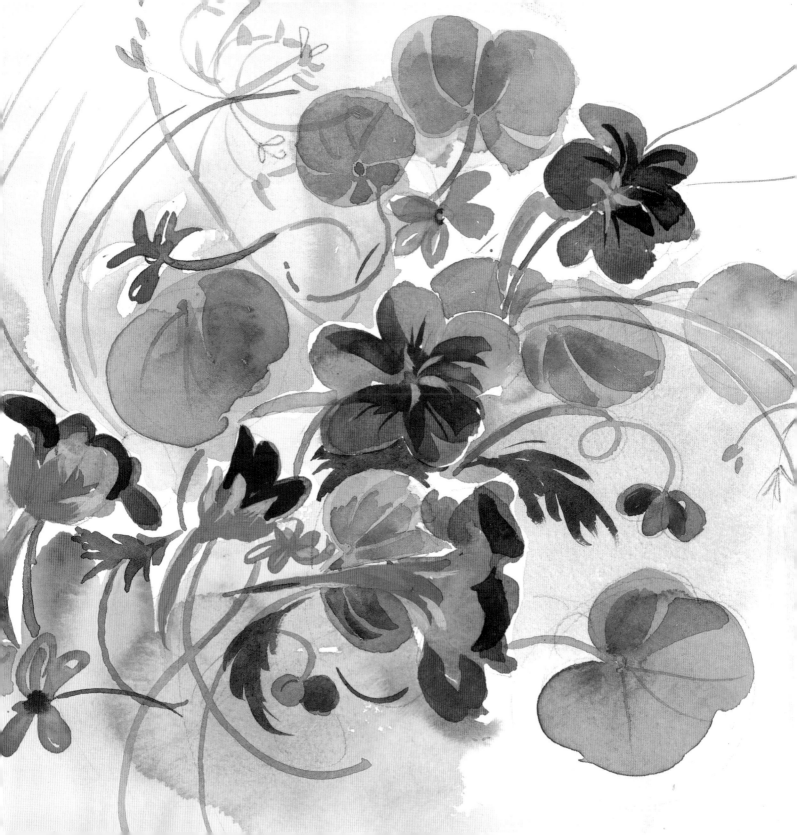

Orchids

Orchids are very beautiful, striking flowers, and some varieties, such as the lovely moth orchid shown here, can be grown indoors on a shady window sill; others can be found outdoors or in greenhouses. The flowers grow on a long stem, away from the glossy leaves, and often have intriguing details on their inner petals.

Colour palette

permanent rose

Winsor yellow

cobalt blue

olive green

sap green

burnt sienna

magenta

Winsor violet

Drawing

Close observation is needed with orchids: there are five petals, of which the central lower one is marked and is quite different to the others. In general the flower is a flat disc shape that faces forwards; practise drawing it from all angles.

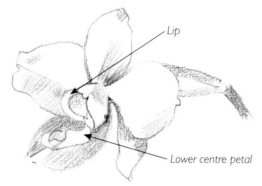

Lip

Lower centre petal

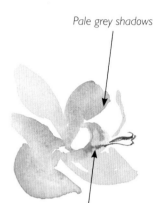

Pale grey shadows

Centre with tongue shape

Flat disc shape

Five petals

Bud

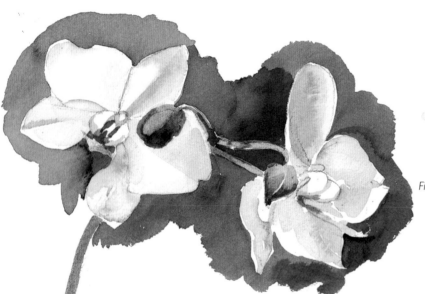

▲ *These beautiful flowers grew on a long stem away from the leaves, so I accentuated this characteristic by painting the stem with no background. The lip and tongue petal was delicate and intricately marked.*

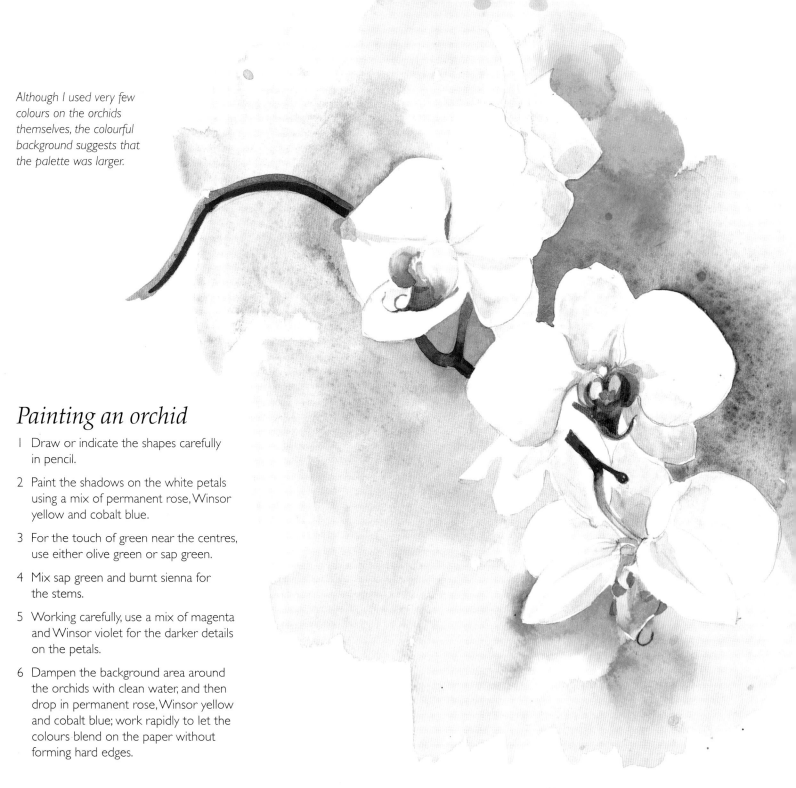

Although I used very few colours on the orchids themselves, the colourful background suggests that the palette was larger.

Painting an orchid

1 Draw or indicate the shapes carefully in pencil.

2 Paint the shadows on the white petals using a mix of permanent rose, Winsor yellow and cobalt blue.

3 For the touch of green near the centres, use either olive green or sap green.

4 Mix sap green and burnt sienna for the stems.

5 Working carefully, use a mix of magenta and Winsor violet for the darker details on the petals.

6 Dampen the background area around the orchids with clean water, and then drop in permanent rose, Winsor yellow and cobalt blue; work rapidly to let the colours blend on the paper without forming hard edges.

Pansies

Who could not like pansies? Their faces seem to look like small cats, and their velvety texture comes in many colours – blue, purple, white, yellow, red and orange. A pansy's flat face is held more or less parallel to the stem and actually faces you, unlike many other flowers, which look up or down.

Colour palette

Winsor violet sap green burnt sienna cadmium yellow

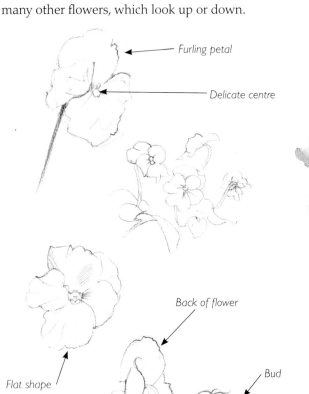

Furling petal

Delicate centre

Back of flower

Flat shape

Bud

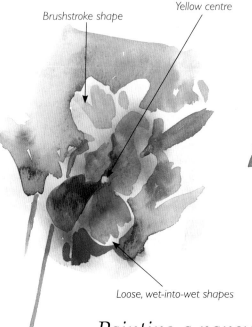

Brushstroke shape

Yellow centre

Loose, wet-into-wet shapes

Drawing

Draw with a soft pencil and turn the pansy this way and that, studying it from every angle. The basic shape is a disc, but the pansy looks different every way it turns. Try to capture the soft, furling petals, and note where the stem springs from. The leaves are often heart-shaped.

> **Tip:** *Become familiar with complementary colours as you can use them to your advantage when painting flowers and backgrounds.*

Painting a pansy

1 Try to avoid drawing, but use a No. 8 round brush to make all the shapes.

2 Using a mid-toned mix of Winsor violet, wash in the petals shapes, leaving a small white space in the centre.

3 While the wash is wet, drop in a darker wash of violet nearer the centre.

4 Paint the leaves and stem with a mid-toned mix of sap green and burnt sienna.

5 Use a darker version of the green mix for the shadows and any details.

6 To finish, add a small dot of strong cadmium yellow in the centre of the pansy.

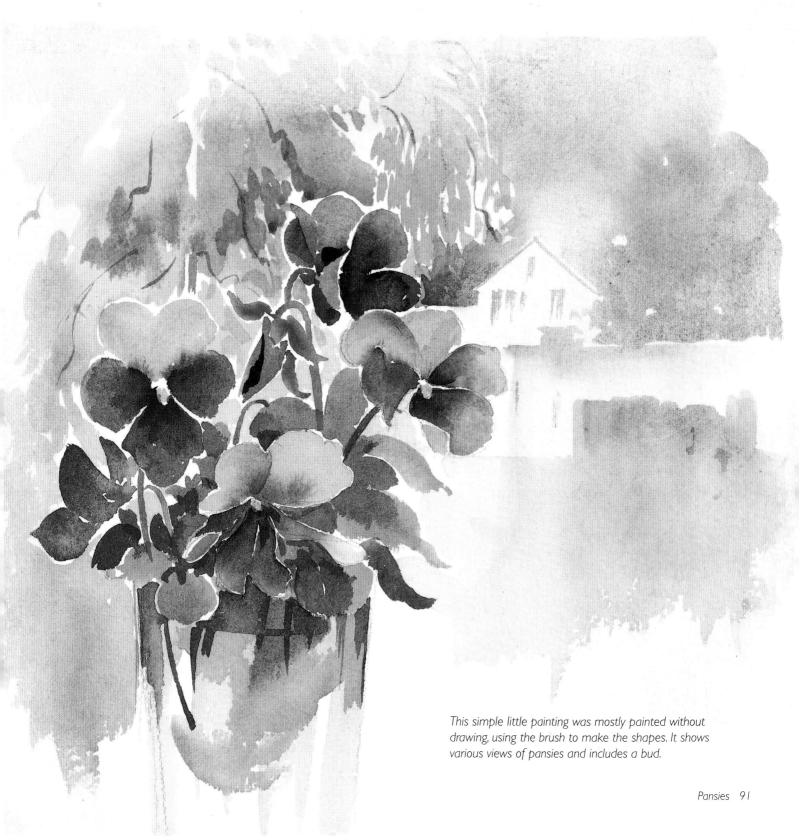

This simple little painting was mostly painted without drawing, using the brush to make the shapes. It shows various views of pansies and includes a bud.

Peonies

Whether perennials or shrubs, peonies are always eye-catching. There are single, semi-double and double varieties in reds, pinks, white and yellow, and they have golden stamens and lovely leaves. If you are, like me, loath to pick them and prefer to paint them in situ, be aware of your eye level as you will be looking down on the flowers.

Colour palette

alizarin crimson French ultramarine Prussian blue

Winsor yellow yellow ochre burnt sienna

Drawing

Like most peonies, the tree peony is loosely a cup or bowl shape. Draw the flower life size and carefully check the light direction as the centre, which is full of stamens, is quite dark. There are two rows of strong, waxy petals.

Leaves

Circular petals

Stamens

Cup shape

Painting a peony

1 Draw the flower, sepals and leaves in pencil.

2 Paint the petals with a light wash of crimson lake or alizarin crimson.

3 While the wash is wet, paint the dark tones and shadows in a stronger wash.

4 When this is dry, paint the stronger darks and shadows with a dark mix of alizarin crimson and French ultramarine.

5 Mix light and darker washes of Winsor yellow and Prussian blue for the leaves, and add a touch of yellow ochre to paint the sepals.

6 Paint the stamens with yellow ochre, and use a mix of Prussian blue and alizarin crimson on the dark side.

Tip: *Practise making really dark tones, using Prussian blue, burnt sienna, French ultramarine and alizarin crimson.*

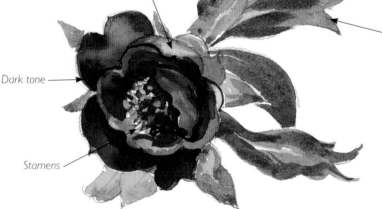

Light tone

Dark tone

Stamens

Leaves

➤ *This tree peony, with its lovely feathery petals, was painted wet-into-wet on stretched paper; the beautiful rich, golden-yellow stamens really stood out.*

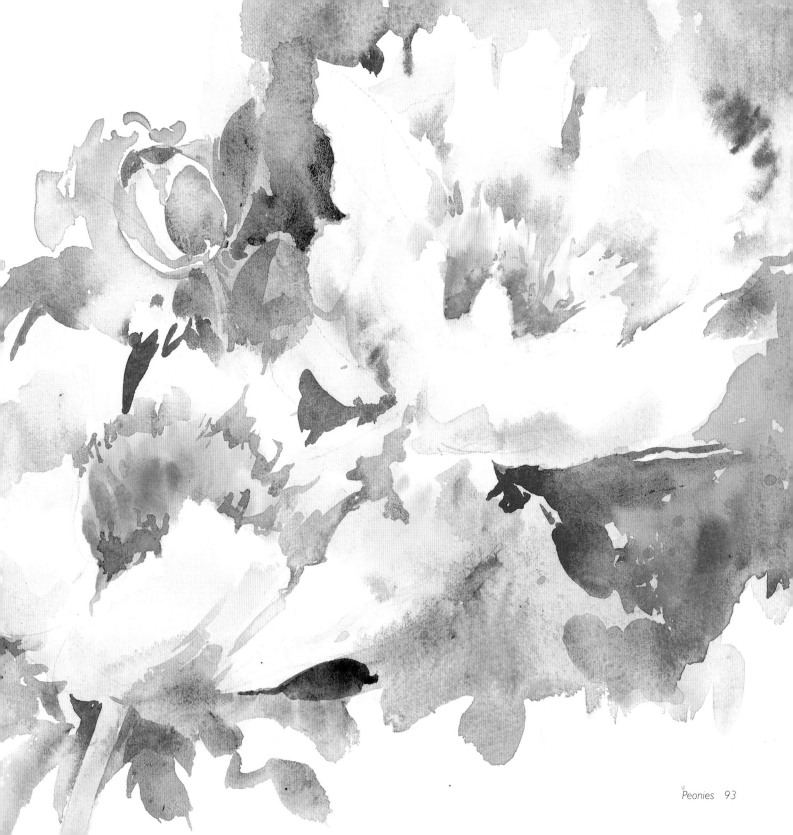

Poinsettias

The actual flowers of a poinsettia are small and insignificant – it is the bracts that are colourful, and these can be brilliant red, pink or white. Poinsettias make very striking house plants; the stems are upright, and the leaves are quite large and form a frame for the colourful bracts.

Colour palette

carmine French ultramarine sap green oxide of chromium

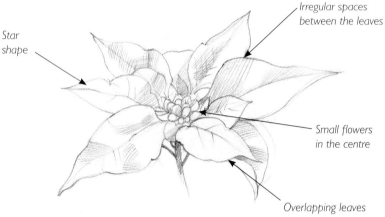

Star shape

Irregular spaces between the leaves

Small flowers in the centre

Overlapping leaves

Drawing

The leaf-shaped bracts form a star shape around the tiny flowers; note the veins and how the bracts appear on the stem. Using a 2B pencil, practise drawing them as if they are leaves.

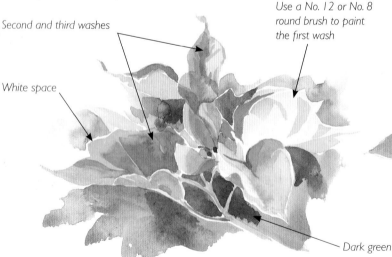

Second and third washes

White space

Use a No. 12 or No. 8 round brush to paint the first wash

Dark green

Painting a poinsettia

1 Draw the bracts in pencil, remembering that they make a sort of star shape; there are six main leaf bracts, with others in between.

2 Using a No. 8 round brush, paint the bracts with a medium wash of carmine.

3 When the wash is dry, paint a darker carmine wash where you see shadows; you can paint this second wash while the first is wet if you leave a tiny gap between the two washes.

4 Mix sap green with a touch of French ultramarine and paint the tiny flowers in the centre.

5 Paint the green leaves using oxide of chromium; this is an opaque green, so paint very carefully using varying tones.

6 As an alternative to using oxide of chromium, you can mix up your own choice of greens to paint the leaves.

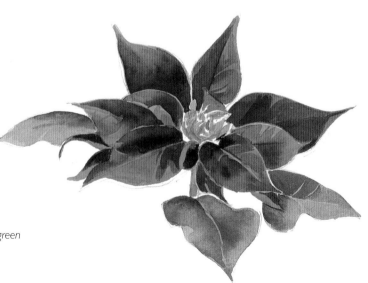

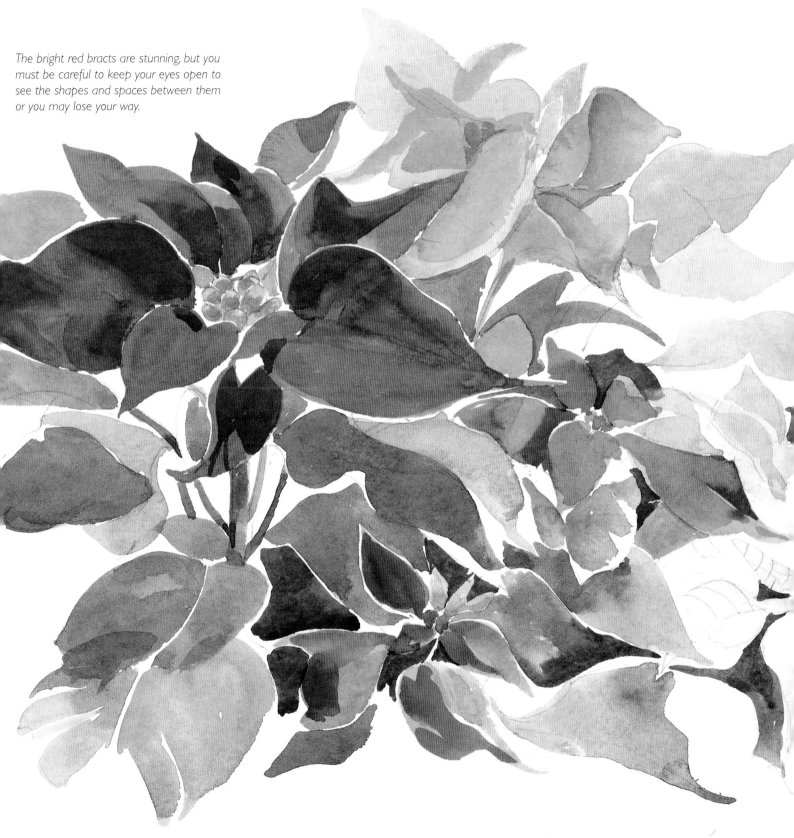

The bright red bracts are stunning, but you must be careful to keep your eyes open to see the shapes and spaces between them or you may lose your way.

Poppies

Poppies are amazing and are always on the list of flowers to paint. In summer, the beautiful, large, bright petals of the oriental poppy invite the brightest of reds, maybe with an underwash of yellow. Annual poppies are just as inviting, and have a tremendous colour range, from red and orange, through pink and purple to white; the seeds, leaves and stems are all decorative.

Drawing

Poppies are bowl-shaped and fairly simple to draw. The soft, furling petals are often veined or pleated; the centres are interesting and have many stamens; and the seed heads and buds can be included. In the case of opium poppies, the blue-grey leaves often wrap around the stem.

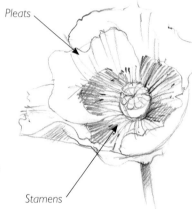

Pleats

Stamens

Colour palette

French ultramarine alizarin crimson cerulean blue Winsor yellow

Painting poppies

1 Draw lightly with a pencil, and include the leaves, buds and seed heads.

2 Mix a purple from French ultramarine and alizarin crimson, and paint over the petals with one pale wash.

3 Using a deeper purple mixed from the same colours, paint the shadows on the petals.

4 Place the 'smudge' at the base of the petals with an even darker tone of purple.

5 Paint the stems, leaves and buds with a blue-green wash mixed from cerulean blue and Winsor yellow.

6 Mix a darker green wash and darken the stems beneath the poppies, then use varying mixes of blue and yellow for shadows on the leaves.

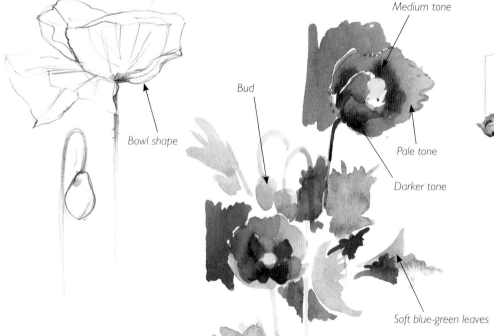

Bowl shape

Bud

Medium tone

Pale tone

Darker tone

Soft blue-green leaves

Tip: For detail, try using a water-soluble coloured pencil – you can draw a line and wet it afterwards for a soft, paint-like effect.

➤ *These large white poppies were growing with others just as impressive and made a striking statement against a darkish background. This was painted quite freely.*

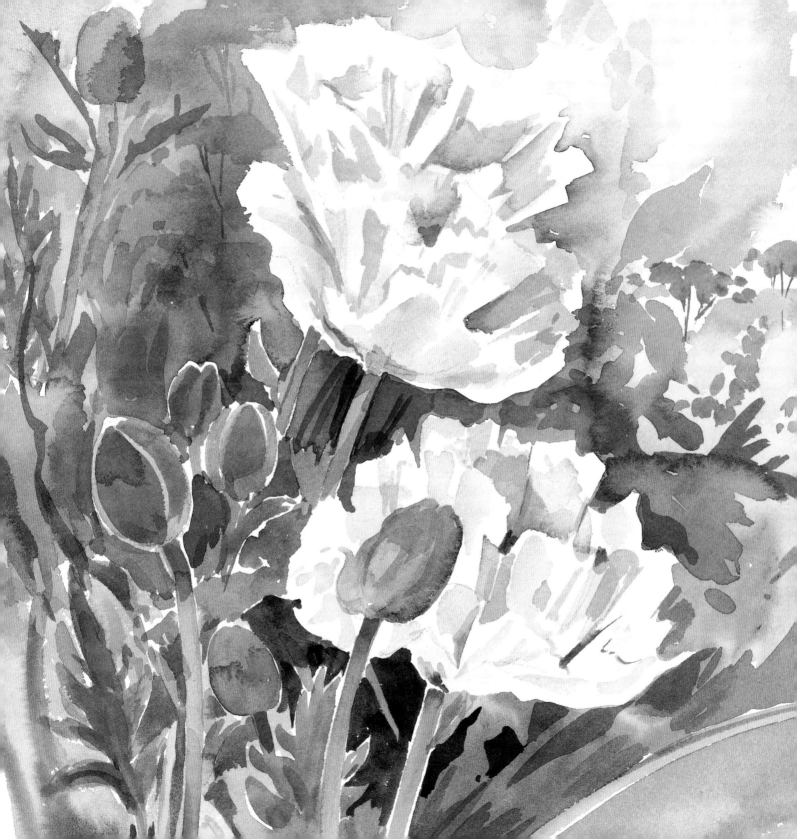

Primroses

The primrose is an early spring flower; the delicate stems hold the flowers mostly upright, and the leaves are crinkled and veined. Wild primroses have very pale yellow flowers with orange markings at the base of each petal; they grow on roadside verges, in ditches and in woodlands. It can be difficult to paint them in situ, but you can find them in the wild flower departments of garden centres.

Colour palette

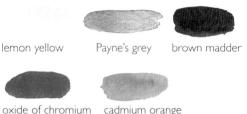

lemon yellow Payne's grey brown madder

oxide of chromium cadmium orange

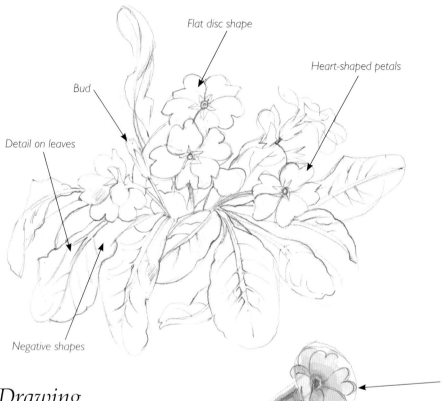

Flat disc shape

Heart-shaped petals

Bud

Detail on leaves

Negative shapes

Painting primroses

1 Draw carefully with a sharp B pencil.

2 Paint the petals with a pale wash of lemon yellow.

3 For the shadows on the petals use a pale wash of Payne's grey.

4 Use a medium wash of brown madder for the stalks, and a pale wash of oxide of chromium for the leaves.

5 While the green is wet on the leaves, paint on a medium wash of the same colour to show the veins and crinkles. Leave some of the first wash showing for the central veins.

6 Mix a darker green wash and continue to paint the leaves, including the smaller veins.

7 Paint the flower centres with cadmium orange, and add a tiny bit of green for the very middle.

Drawing

Draw life size using a sharp 2B pencil. The flowers have pretty heart-shaped petals and are flat disc shapes with a longish calyx. Make a study of the whole plant, including the leaves.

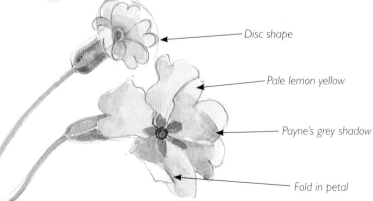

Disc shape

Pale lemon yellow

Payne's grey shadow

Fold in petal

➤ This was difficult to paint in a free way, but I wanted to capture a feeling of spring and so included a blue sky. In your paintings you can include items of interest such as leaves, twigs, small branches and grass.

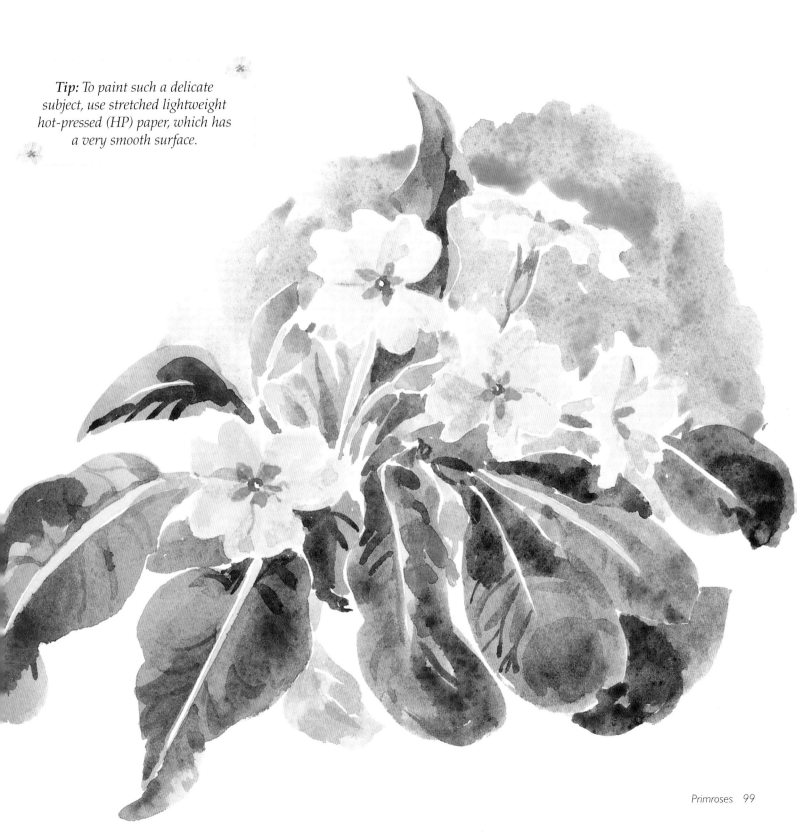

Tip: To paint such a delicate subject, use stretched lightweight hot-pressed (HP) paper, which has a very smooth surface.

Red hot pokers

These spectacular flowers really live up to their name, with lovely shades of red, orange and yellow. Some are tubular in shape, others more rounded, but they are all fascinating to paint. The heads are composed of many small florets, so practise making an overall wash and then adding to this either while it is wet or when it has dried – both ways can reward you with striking results.

Colour palette

cadmium orange cadmium yellow cadmium red

raw umber sap green

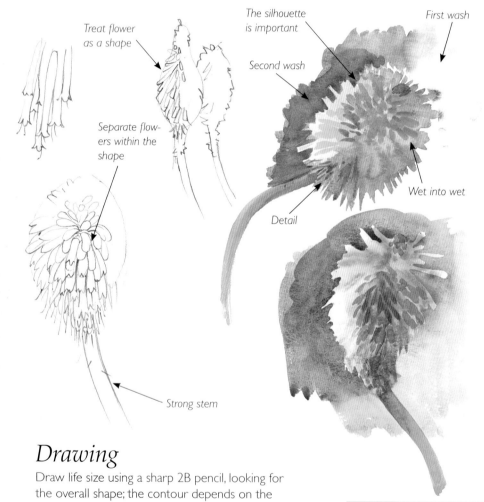

Treat flower as a shape

Separate flowers within the shape

The silhouette is important

Second wash

First wash

Detail

Wet into wet

Strong stem

Painting a red hot poker

1 Using a No. 12 round brush, make the shape of the flower with a pale wash of cadmium orange.

2 While this is wet, drop in further washes of cadmium yellow and cadmium red.

3 Use a mix of raw umber and sap green to paint the shadow side and underneath of the flower; no detail is needed at this stage.

4 Depending on the background, decide on the silhouette and cut in with a dark background or define the edges on a light background.

5 Now add detail with a small brush, painting some of the individual florets with darker tones of orange or red.

6 Paint the stem with a mix of sap green and raw umber, remembering that it should look strong enough to bear the weight of a heavy flower.

➤ *Painting these Kniphofia raised the question of backgrounds; the flowers hardly need one, but the leaves of this plant were in a clump at the base and looked untidy. I painted the sky, the flowers and grasses, and finally the background.*

Drawing

Draw life size using a sharp 2B pencil, looking for the overall shape; the contour depends on the variety of flower. Don't be put off by the many intricate florets, which are tubular and flower from the base first. The stems are strong and the strappy leaves come from the base.

Tip: When painting a positive shape for a background, as here, be careful with the edges of the silhouette that is your subject.

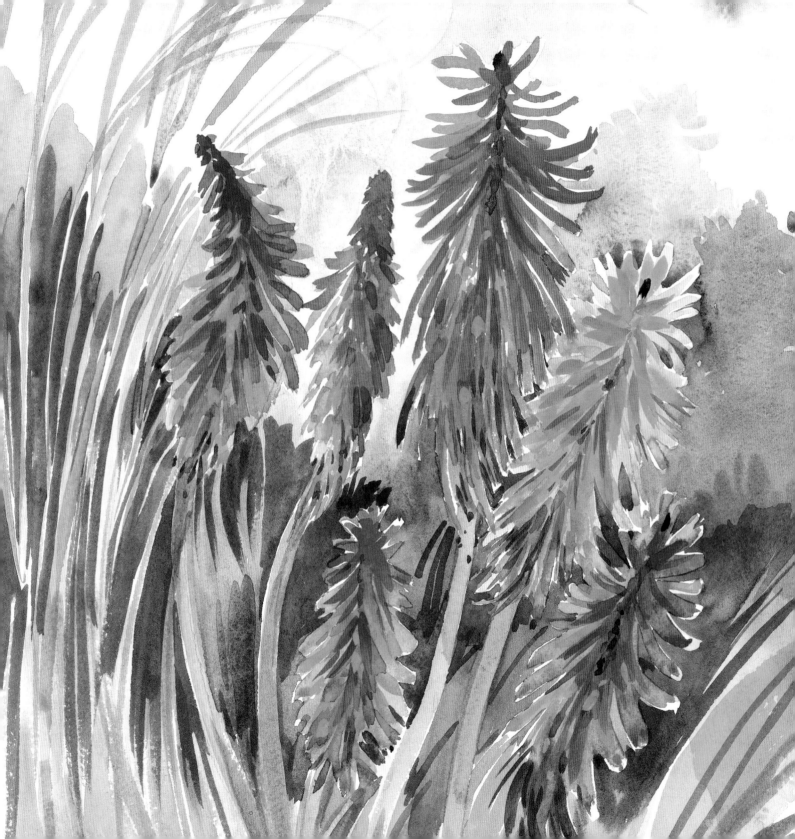

Rhododendrons

Rhododendrons appear in clusters, and the individual flowers are bell-shaped and strikingly beautiful. The colours are delicate; sometimes the flowers are spotted or the flowers graduate from one colour to another. The stamens and pistil are very decorative. Azaleas are grouped with rhododendrons – they usually have smaller flowers and make very decorative indoor plants.

Colour palette

alizarin crimson permanent rose French ultramarine

sap green yellow ochre burnt sienna

Drawing

Note the direction of light and draw the individual, bell-shaped flowers in clusters with a 2B pencil, noting the shape of the petals. The leaves are important and act as a foil to the flowers. Choose a size of paper to suit the subject – don't draw too small – and avoid using an eraser as this can roughen the paper surface.

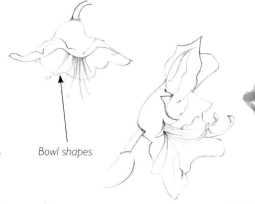

Bowl shapes

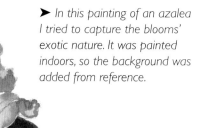

Stamens

Wet into wet

➤ *In this painting of an azalea I tried to capture the blooms' exotic nature. It was painted indoors, so the background was added from reference.*

Darker tone

Painting rhododendrons

1 Draw the shapes lightly in pencil.

2 Dampen the flower clusters with clean water, then use a No. 12 round brush to drop in a pale pink wash of alizarin crimson that fills the area.

3 While this is wet, paint the shadows and centres with a mix of permanent rose and French ultramarine, paying attention to the direction of light.

4 Mix a light green from sap green and yellow ochre, and paint the leaves.

5 When this wash is dry, mix a darker green from sap green and burnt sienna and paint over the leaves, leaving the first wash to indicate the veins.

6 Strengthen the flowers using varied washes of pink and pale grey, mixed from ultramarine and permanent rose.

7 Use a smaller brush, such as a No. 4 round, to paint the stamens in yellow ochre, the buds in a darker pink, and the stems in burnt sienna.

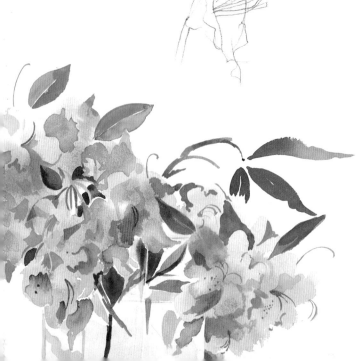

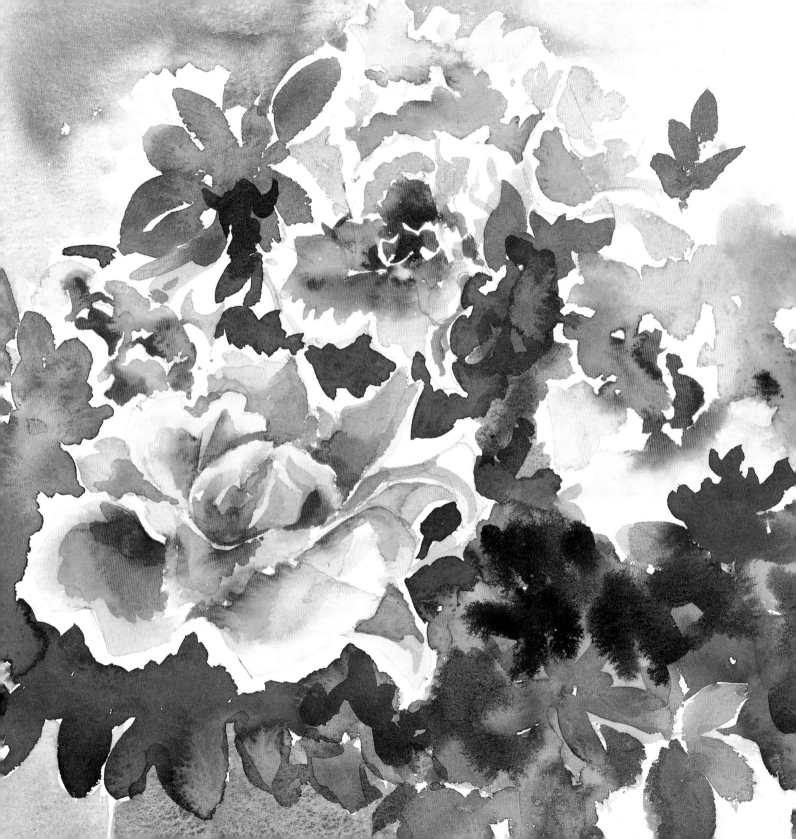

Romneyas

These stunning white flowers, also known as Californian tree poppies, are an artist's dream. They may take a while to become established in a garden, but once there, they provide many subjects. The beautiful, large flowers have delightful, crinkled petals, which shimmer in even a light breeze, and the stamens are a brilliant yellow – in fact, the flower vaguely resembles a poached egg.

Colour palette

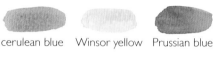

cerulean blue Winsor yellow Prussian blue

brown madder cadmium yellow yellow ochre

Drawing

These flowers are based on a circular shape; be aware of the petals, and practise drawing ellipses. The leaves are decorative and divided; the details of the petals and the centre can be added later.

Crimped and pleated petals

Disc shape

Large, central stamens

Ragged edges

Painting romneyas

1 Draw lightly, preferably life size.

2 Paint the centres using cadmium yellow.

3 White flowers need some sort of colour behind them to stand out: I used the leaves as a background. Contrast is very important here.

4 Paint the leaves where required using a mix of cerulean blue and Winsor yellow; mix a darker version of this by adding Prussian blue and use for the shadows.

5 Use a grey, made of cerulean blue and brown madder, for the wrinkles and pleats on the petals.

6 Make a light green mix from cerulean blue and cadmium yellow for the stems, and use yellow ochre for the detail on the centres and stamens.

Colour around flower to highlight white

Allow pencil drawing to show through

Large, central stamens: cadmium yellow with a little yellow ochre

Ragged edges

Veins and pleats in mid-tone grey: cerulean blue and brown madder

➤ *For the grey-green leaves I mixed cerulean blue and Winsor yellow, strengthening the colour with Prussian blue. The actual background consisted of a very dark and dense laurel hedge. Painting the flowers at different times of day meant that I used a range of colours and mixes.*

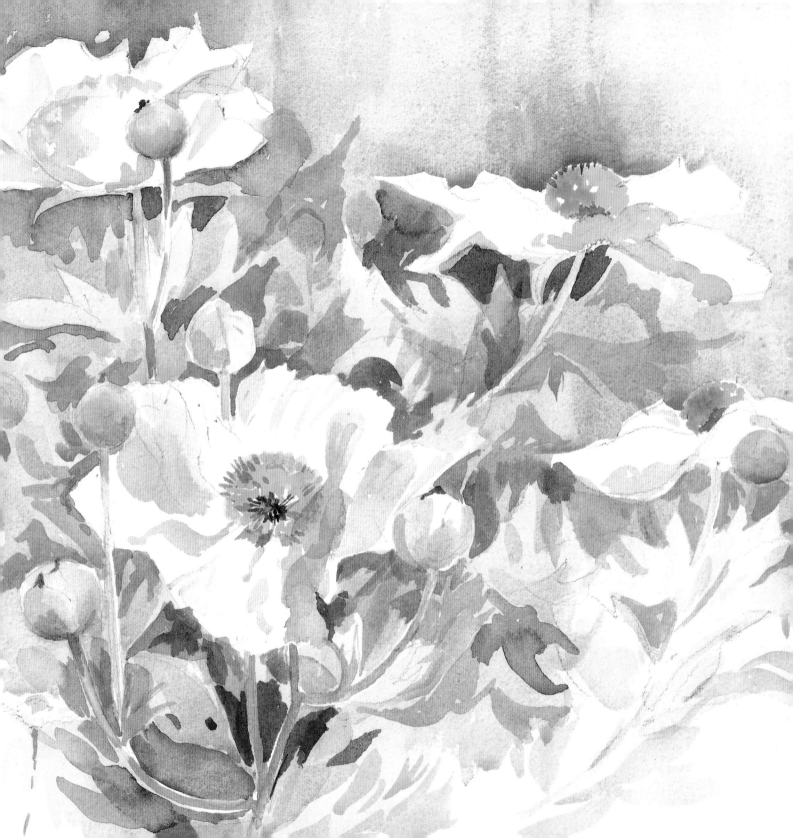

Roses

Roses have such perfect colours and are so beautiful from bud to full-blown flower. Roses with many petals have to be drawn carefully – the petals spiral and overlap and turn gracefully at the edges – while single-petalled roses are much easier to draw. Small, single roses that bloom en masse can be useful as background flowers.

Colour palette

permanent rose

French ultramarine

Winsor yellow

yellow ochre

sap green

brown madder

Drawing

Draw the main shapes first, recognizing the essential cup or bowl shape, and work around petals that overlap and spiral; practise capturing this. The petals also fold over at the edges.

Most roses open right out

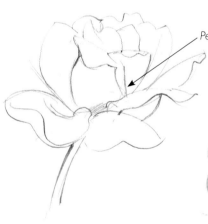

Petals overlap in spirals

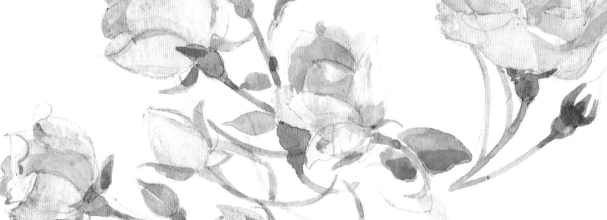

Painting a rose

1. Draw the shapes lightly in pencil.

2. Paint over the entire flower shape with a pale wash of permanent rose.

3. Using a darker tone, such as a pinky-grey mixed from permanent rose, French ultramarine and Winsor yellow, paint in the shadows to give an idea of form.

4. Make up a mix of sap green, yellow ochre and ultramarine for the sepals, buds and leaves.

5. Paint the stems with a pale wash of brown madder, using single brushstrokes.

6. Using a No. 4 round brush and darker mixes of the colours, put in any fine details.

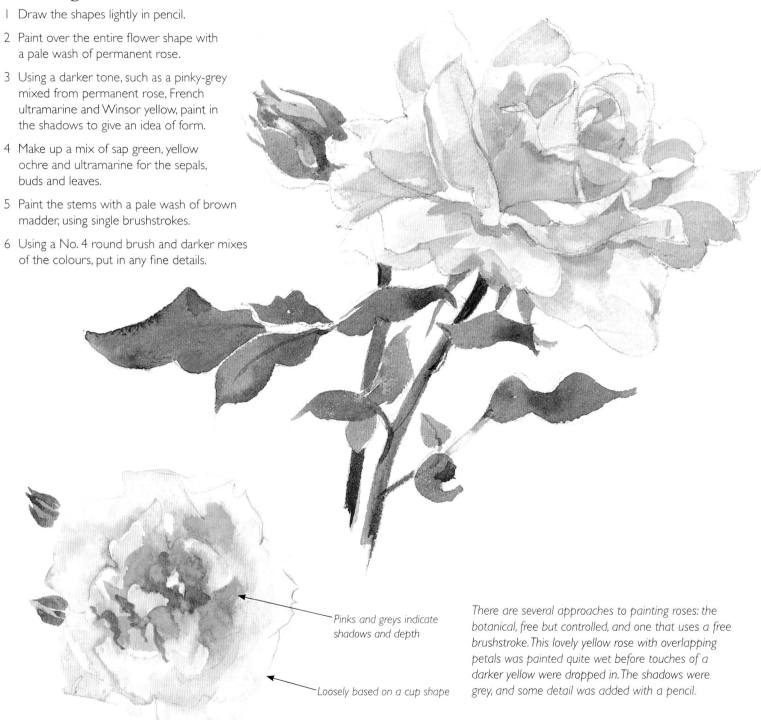

Pinks and greys indicate shadows and depth

Loosely based on a cup shape

There are several approaches to painting roses: the botanical, free but controlled, and one that uses a free brushstroke. This lovely yellow rose with overlapping petals was painted quite wet before touches of a darker yellow were dropped in. The shadows were grey, and some detail was added with a pencil.

Snapdragons

The snapdragon is a lovely summer flower, delighting children and adults alike with its playful shape. The flower is in two parts and is known as a lipped flower. The flowers grow around a single stalk, rather like a foxglove, and come in an array of mouth-watering colours.

Colour palette

magenta

cadmium red

alizarin crimson

sap green

burnt sienna

French ultramarine

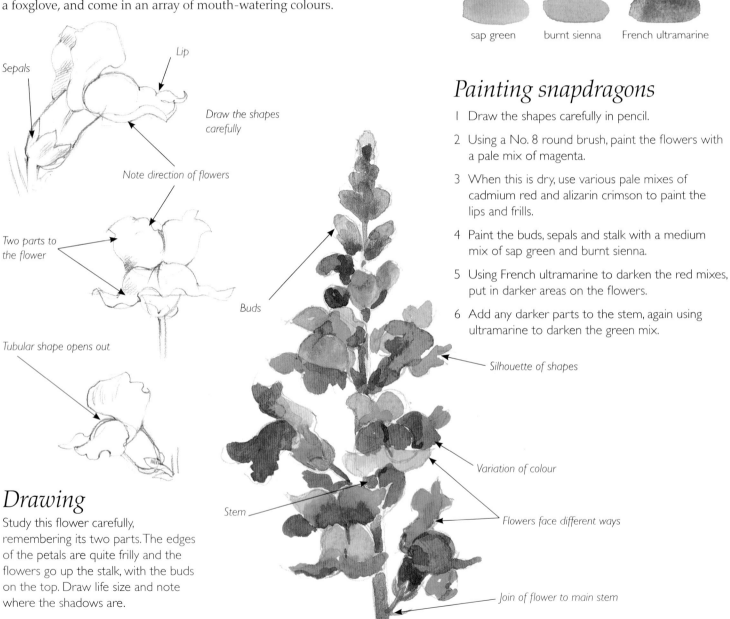

Sepals

Lip

Draw the shapes carefully

Note direction of flowers

Two parts to the flower

Tubular shape opens out

Buds

Silhouette of shapes

Variation of colour

Stem

Flowers face different ways

Join of flower to main stem

Painting snapdragons

1 Draw the shapes carefully in pencil.

2 Using a No. 8 round brush, paint the flowers with a pale mix of magenta.

3 When this is dry, use various pale mixes of cadmium red and alizarin crimson to paint the lips and frills.

4 Paint the buds, sepals and stalk with a medium mix of sap green and burnt sienna.

5 Using French ultramarine to darken the red mixes, put in darker areas on the flowers.

6 Add any darker parts to the stem, again using ultramarine to darken the green mix.

Drawing

Study this flower carefully, remembering its two parts. The edges of the petals are quite frilly and the flowers go up the stalk, with the buds on the top. Draw life size and note where the shadows are.

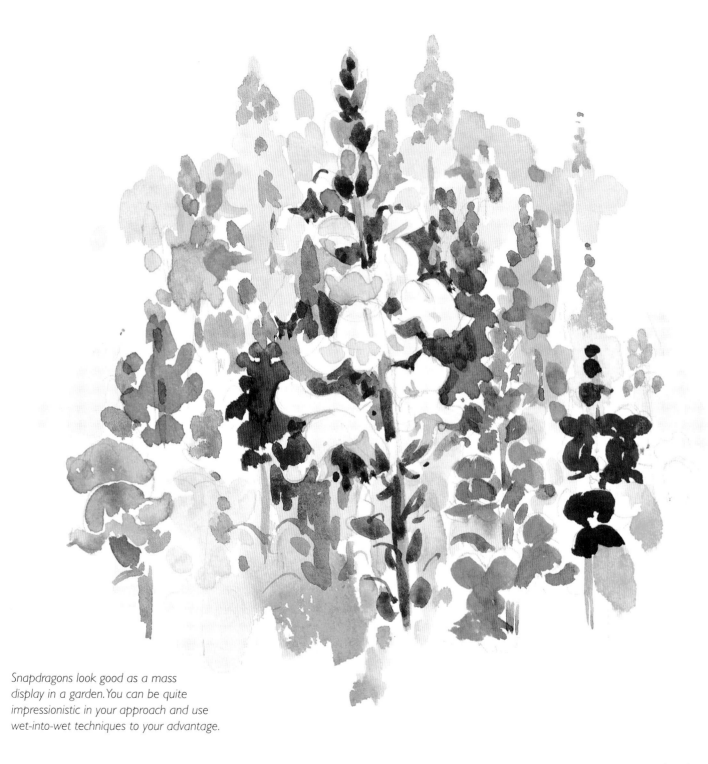

Snapdragons look good as a mass
display in a garden. You can be quite
impressionistic in your approach and use
wet-into-wet techniques to your advantage.

Snowdrops

Snowdrops appear around the New Year and are the classic winter flowering plant, loved by everyone. The small white flowers have petals of incredible purity, and the inner petals have green markings. Snowdrops grow in clumps of grass and, being small, are quite difficult to paint.

Colour palette

burnt sienna sap green brown madder French ultramarine

Painting snowdrops

1 Draw the shapes in pencil on hot-pressed (HP) paper.

2 Leave the white of the paper for the petals, or use masking fluid to make the shapes.

3 Use a No. 4 round brush to paint the stem and calyx with a mix of burnt sienna and sap green.

4 Paint the leaves with a similar mix, only slightly more blue.

5 Mix French ultramarine and brown madder to make a light grey for the shadow areas.

6 After removing the masking fluid, the white flowers may need a background – a light grass green or a soft grey are good choices.

Use a sharp pencil

Lampshade shape

Drawing

Use a sharp 2B pencil to draw snowdrops both in bud and open. The buds are teardrop-shaped, but the open flowers resemble a hanging lampshade. Some snowdrops have double petals.

Tip: *It is quite difficult to get the scale of snowdrops right – they are small, and you really need to have them at eye level to appreciate their size. To achieve the detail, it's important to have good points on your brushes.*

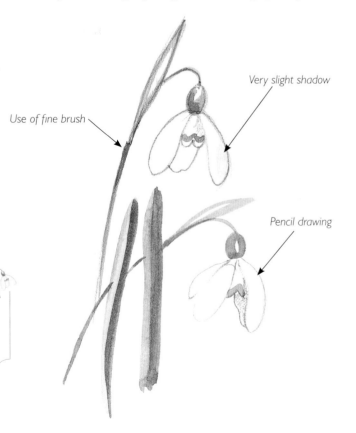

Very slight shadow

Use of fine brush

Pencil drawing

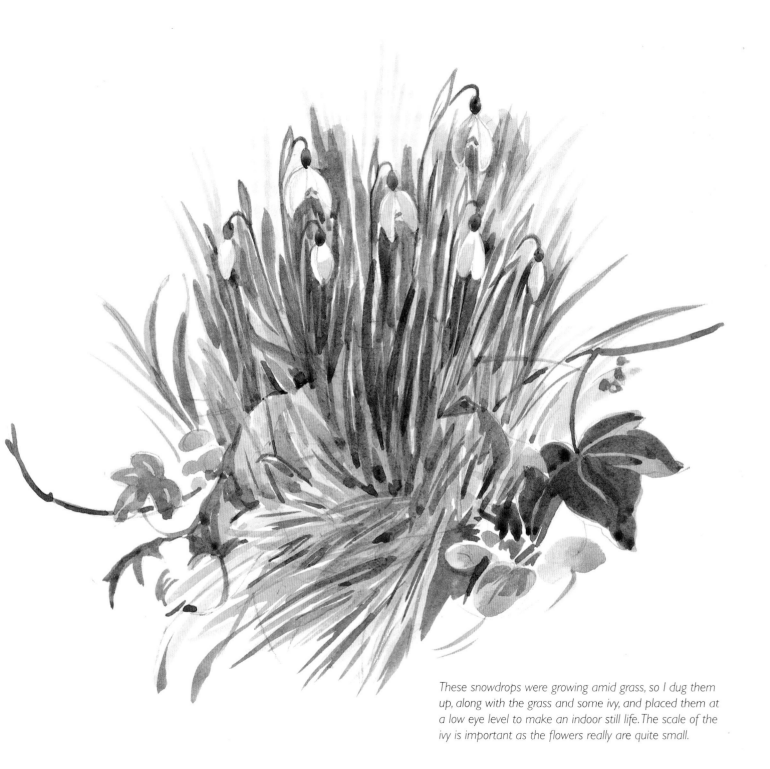

These snowdrops were growing amid grass, so I dug them up, along with the grass and some ivy, and placed them at a low eye level to make an indoor still life. The scale of the ivy is important as the flowers really are quite small.

Sunflowers

No matter how many times they have been painted, sunflowers are still a perenially popular subject. They can be painted as they are, in vases, as still lifes, in fields, or simply as decorative seed heads. The colours of sunflowers range from yellow to dark red, and the centres can be dark sepia, umber and green. Cadmium yellow, used here, is a bright opaque colour – use it pale or dark – and cadmium orange has a rich brilliance.

Colour palette

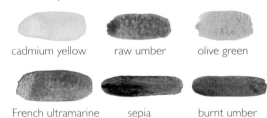

cadmium yellow raw umber olive green

French ultramarine sepia burnt umber

➤ *The brilliance of these sunflowers is enhanced by the dark background; they were painted at eye level. There is a great range of colours available, with at least seven different yellows you could use; match the flowers' yellow against a colour chart. I love strong colour, but if you prefer to work in a paler key, make sure you keep all the tonal values in keeping.*

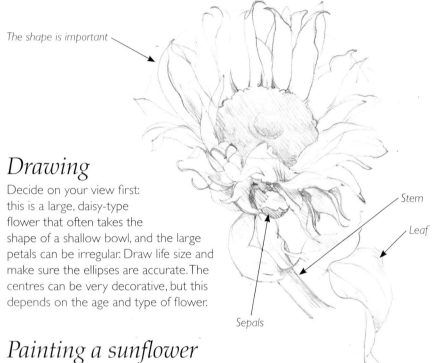

The shape is important

Stem

Leaf

Sepals

Drawing

Decide on your view first: this is a large, daisy-type flower that often takes the shape of a shallow bowl, and the large petals can be irregular. Draw life size and make sure the ellipses are accurate. The centres can be very decorative, but this depends on the age and type of flower.

Tip: To mix a really dark colour without using black, try using Prussian blue, burnt sienna and alizarin crimson.

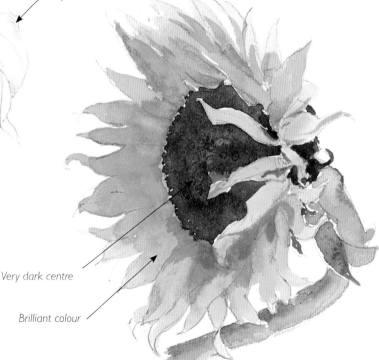

Very dark centre

Brilliant colour

Painting a sunflower

1 Draw from life with a pencil, taking care with the shapes.

2 Paint the petals with a pale wash of cadmium yellow.

3 Use a darker shade of cadmium yellow to indicate the shadow side of the petals; you can do this wet on dry or wet into wet.

4 Paint the detail on the petals with raw umber.

5 The stem and sepals should be olive green, with a touch of French ultramarine added to strengthen any dark areas.

6 Mix sepia and burnt umber to paint the centre of the flower; you may want to use olive green for the middle part.

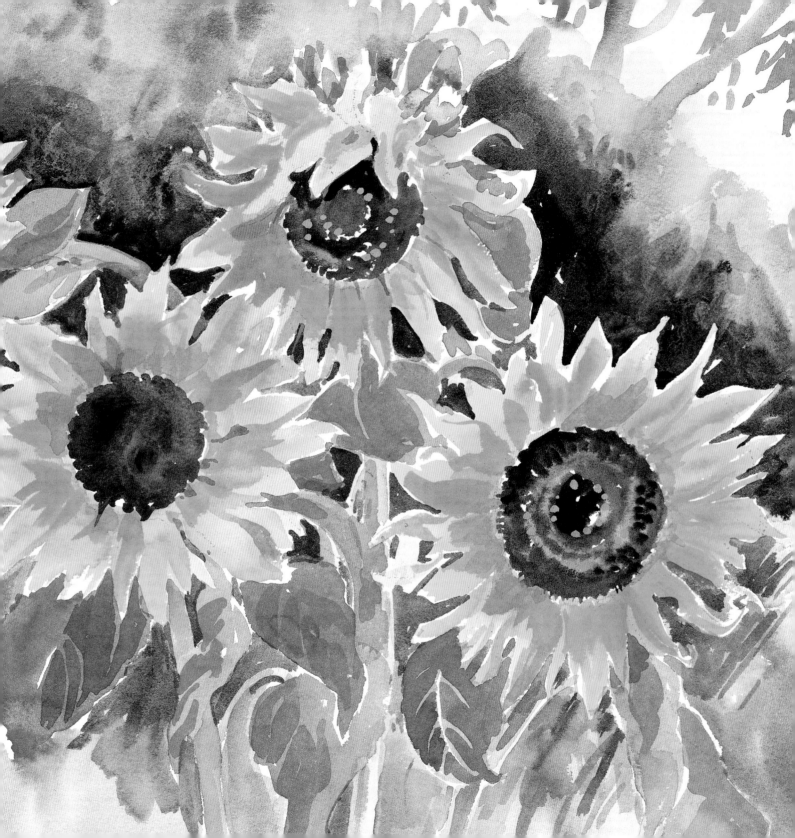

Sweet peas

The delicate petals and fragrance of sweet peas capture our hearts, and the soft colours, mostly pastel shades, but sometimes purple and deep red, make us stretch for our paints; the flowers seem to be made for the transparency of watercolours. Look at the flowers carefully, and try to capture the airy nature and fragility of the petals.

Colour palette

alizarin crimson ultramarine violet oxide of chromium

Painting a sweet pea

1 Draw the shape with a pencil.

2 Paint the upper petals with a clean, pale wash of alizarin crimson.

3 Follow this with a pale wash of ultramarine violet for the lower petals.

4 While the washes are wet, drop in darker tones to show contours.

5 Continue to darken the petals; you can lighten areas by lifting out the paint using a clean, dry brush.

6 Paint the stem and sepals with oxide of chromium.

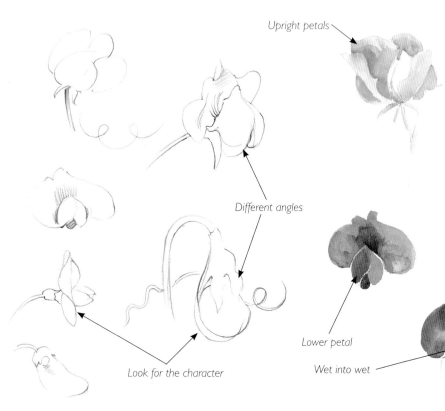

Upright petals

Different angles

Look for the character

Lower petal

Wet into wet

Side petal

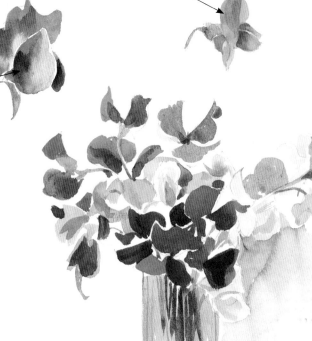

Drawing

The sweet pea is a member of the pea family; the flower consists of three parts, with one upright petal, a side petal and a keel or lower petal. The petals are soft and often furling. Draw it from all angles to understand the shape.

Tip: *Achieving clean colours is easy: use the colour neat, make the mix on the paper, or overlay to make the required colour. More than three colours mixed will be muddy.*

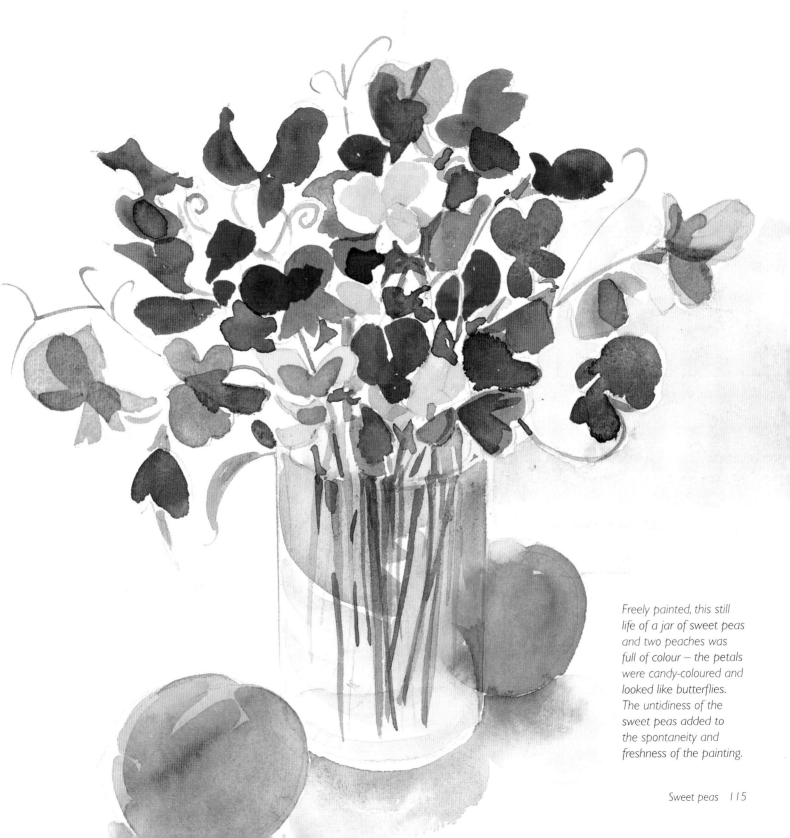

Freely painted, this still
life of a jar of sweet peas
and two peaches was
full of colour – the petals
were candy-coloured and
looked like butterflies.
The untidiness of the
sweet peas added to
the spontaneity and
freshness of the painting.

Tulips

With a huge range of coloured petals, tulips are the national flower of Holland, and the tulip fields there are definitely worth visiting. The goblet-shaped flowers often open right out, and tulips look lovely when combined with forget-me-nots and wallflowers.

Colour palette

permanent rose Winsor yellow cerulean blue French ultramarine

Drawing

Decide on the shape and draw the flower life size; consider the petals, their shapes and curves and how they relate to the stem. The shadows and tones will help the form. Draw a leaf or two as well.

Shape

Leaf

Tone

Light

Stem

Painting a tulip

1 Draw the shape, stem and one or two leaves with a pencil.

2 Note the direction of light and any sheen on the petals.

3 Using a pale pink wash of permanent rose, paint the flower.

4 Drop in darker tones of pink for the further petals.

5 Mix Winsor yellow and cerulean blue to make a soft green for the stem and leaves.

6 Add details, the shadow on the stem and any tone on the petals, using a light wash of French ultramarine.

Tones of pink

Slight detail

Tip: *Some tulips turn to the light; the petals can fall, and the colours can fade. Be aware of this, and time your painting to catch the flowers at their best.*

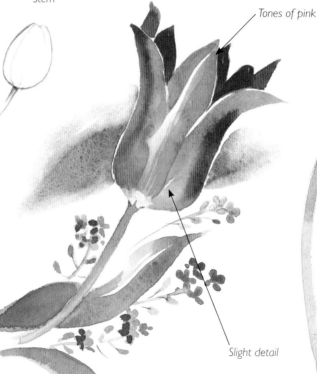

➤ *These lovely tulips opened out as soon as I put them in water. The leaves were floppy, but the flowers were stunning and lasted for weeks.*

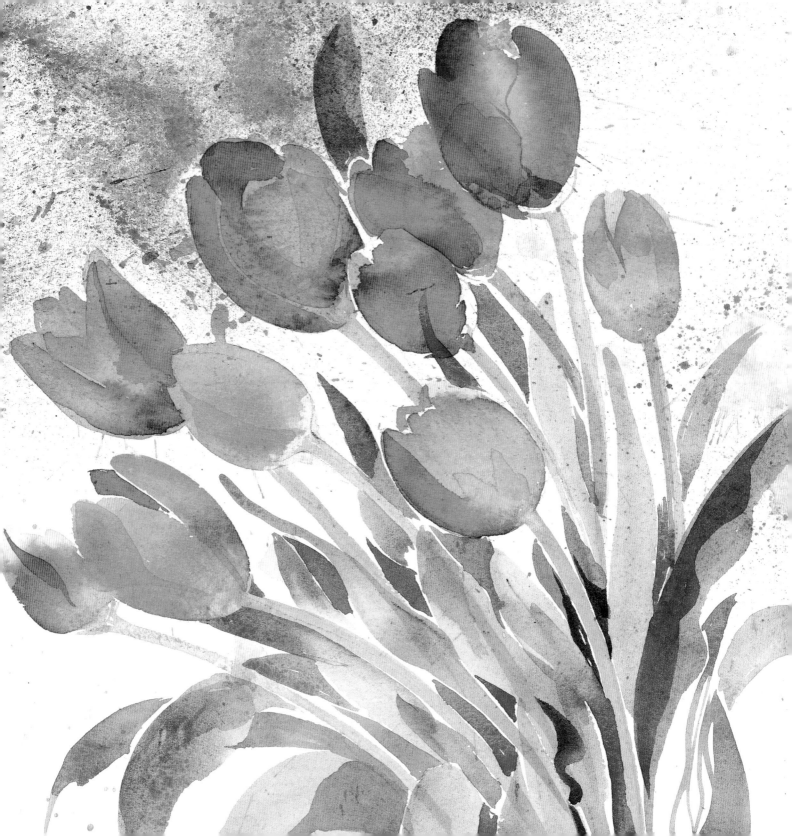

Water lilies

Water lilies always look easy to paint as they are laid out on the water; the leaves are simple shapes, and mostly you look down on them. Decide on a viewpoint and don't deviate from it as there is a certain amount of perspective in the leaves. You can paint a landscape view or a close-up. Buds add variety, and you can include other water plants and even fish.

Colour palette

 cadmium red
 Winsor yellow
 French ultramarine
 brown madder

 yellow ochre
 sap green
burnt sienna

Drawing

Depending on the variety, water lilies are often cup- or bowl-shaped; when looking down on the flower, it can appear star-shaped. The stamens are often prominent. Draw the shape first, and then add the petals. The leaves are rounded and flat.

Flat, floating leaves sometimes come out of the water

Cup shape

Stamens

Painting a water lily

1 Draw the shape and petals with a pencil.

2 Use a pale apricot mix of cadmium red and Winsor yellow to paint the whole flower except the stamens.

3 When this wash is dry, use a medium tone of the mix to paint the shadow side.

4 Mix French ultramarine and brown madder to make a grey, and use this to paint details on the flower.

5 Paint the stamen area with Winsor yellow.

6 When this is dry, use yellow ochre for the details.

7 Make varying mixes of sap green and ultramarine for the water and the petals, adding burnt sienna for the brown areas.

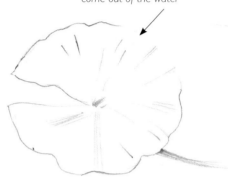

Cup or bowl shape

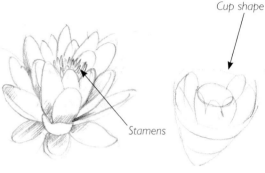

Petals

Shadows on petals

Silhouette is important

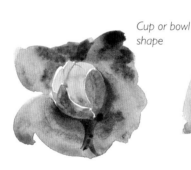

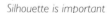

▶ *In this painting of water lilies on a pond, I lightened the leaves as they were mottled and varied in colour.*

Closing thoughts

It has been a privilege to take part in the production of this book. I have been able to draw and paint both common and unusual flowers and plants, and it has been good to have a goal and direction. I've learned that one's style can change quite dramatically, but one thing remains constant: watercolour is a challenging medium, but its colour, light and transparency are ideal for flowers. I hope that you will also learn from these examples and get as much pleasure from painting them as I have.

I would like to thank the staff at David & Charles for their help and support, and also my family and friends, who encourage me so much.

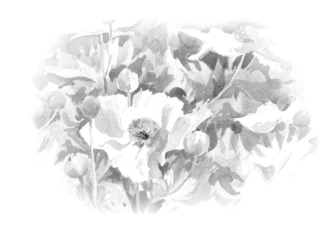

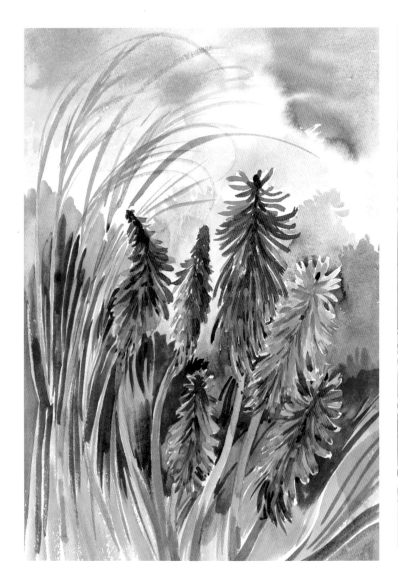

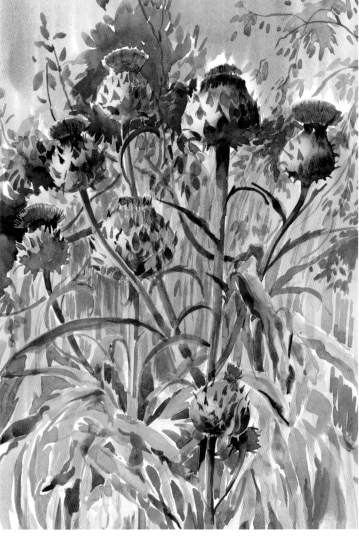

Index